IMAGES of America

FULTON
AND THE
OSWEGO RIVER

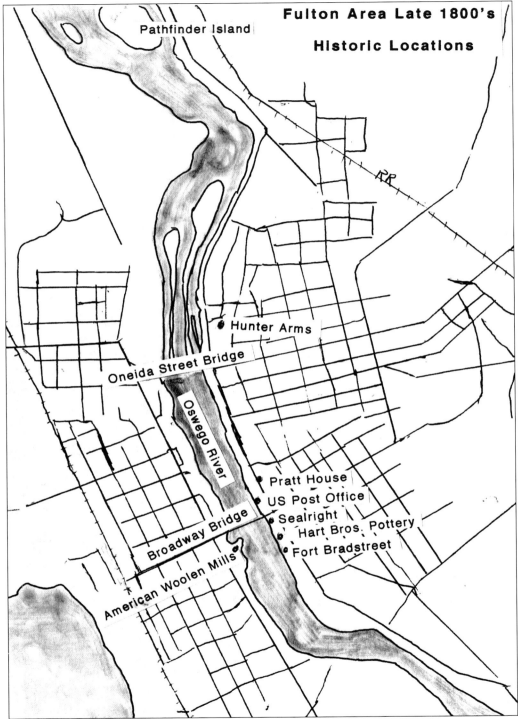

HISTORIC LOCATIONS. This late-1800s map shows some of the historic locations in the Fulton area.

IMAGES
of America

FULTON
AND THE
OSWEGO RIVER

Friends of History in Fulton

Copyright © 2001 by Friends of History in Fulton, New York, Inc.
ISBN 978-0-7385-0933-4

Published by Arcadia Publishing
Charleston, South Carolina

Printed in the United States of America

Library of Congress Catalog Card Number: 2001091704

For all general information contact Arcadia Publishing at:
Telephone 843-853-2070
Fax 843-853-0044
E-mail sales@arcadiapublishing.com
For customer service and orders:
Toll-Free 1-888-313-2665

Visit us on the Internet at www.arcadiapublishing.com

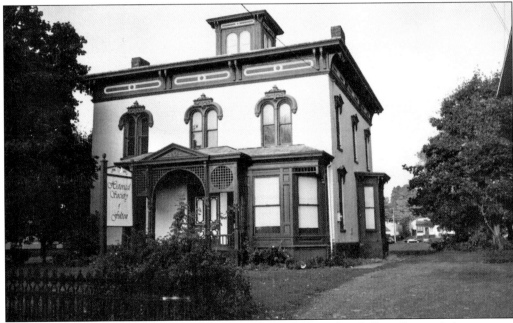

THE PRATT HOUSE. The Pratt House was built in 1863 on South First Street. It has a stone foundation with brick walls painted pale yellow. The two-story house was built wall-over-wall, with two bay windows. The windows are four-over-four and are double hung. The roof is covered with tin that was imported from England. The house is topped by a cupola, which allowed members of the family to view the Oswego Canal and their boats. The Pratt House is the museum building of the Friends of History in Fulton, New York, Inc.

Contents

Acknowledgments 6

Introduction 7

1. The Early Years 9

2. The Erie Canal Influence 19

3. Building the Barge Canal 31

4. Streets and Buildings 49

5. Fulton Industries along the River 83

6. Recreation and Leisure Connected to the River 99

7. The Later Years 107

Acknowledgments

Fulton and the Oswego River is the result of research done at the Pratt House, the museum building of the Friends of History in Fulton, New York, Inc., during the spring of 2001. Members of the board of directors participating in the production of the book were Thela P. Squires and Glenn W. Clark, both retired Fulton educators. Also involved in the production of the book were Carrie R. Butler, coordinator of the museum from 1989 to 1996, and Elma Smith, president of the board of directors.

The Friends of History, located at 177 South First Street, was founded in 1979 by civic-minded Fulton-area residents interested in saving and preserving the John Wells Pratt House, an 1863 Italianate-style home. The Timothy Pratt family, early settlers of Fulton, built and operated a stone gristmill a quarter of a mile south of the homesite. Timothy Pratt's son, John Wells Pratt, had an extensive boatbuilding, repair, and shipping business and was a prominent businessman. The house was occupied by members of the Pratt family until 1975 and, in 1979, it became the headquarters for a local history museum operated by the Friends of History. The purpose of the society is to obtain, preserve, and exhibit items pertinent to local history. The society also maintains a library for local and genealogical research. The maintenance of the Pratt House and the administration of the historical society's programs are funded through memberships, donations, and fund-raisers, such as the sale of this book. The officers and directors of the Friends of History are most grateful for your support through your purchase of the book.

INTRODUCTION

Stop. Take a look around you. Imagine snow and ice as far as the eye can see. The city of Fulton, along with most of the northern part of the state of New York, was once covered with ice during the Wisconsin glacial advance thousands of years ago. In approximately 10,000 B.C., the Port Huron substage of the Wisconsin glacier slowly retreated northward, leaving a large lake called Lake Iroquois. Lake Iroquois covered the area now occupied by Lake Ontario to the north, Oneida Lake to the east, and the Finger Lakes to the south. The lake drained eastward from Rome toward Albany via the Mohawk River into the Atlantic Ocean.

Some 2000 years later, c. 8,000 B.C., the glacier receded farther north, past the Covey Pass in Quebec, Canada, causing the outlet channel of Lake Iroquois to shift from Rome to the St. Lawrence Valley. Although seemingly unimportant in and of itself, the shifting of the outlet caused the lake to drain. Lake Ontario, the Oswego River, and Lake Ne-ah-tah-wanta were left in its path, along with the land upon which cities have arisen.

Waterways were the roads for early man, and in this area the Oswego River was important for travel. The Oswego River is one of the few rivers in the world that flows northward. The river begins where the Oneida River meets the Seneca River at a point called Three Rivers. The Oswego River is 23.5 miles, dropping more than 113 feet to empty into Lake Ontario. The original Oswego River was narrower, lower in depth, had higher banks, and was more violent than it is today. Modern-day dams, built for navigation and power, control the river's natural fury.

When the white man came in the mid-1600s, Native American culture underwent extreme changes. Stone tools and weapons were replaced with iron, and pottery was replaced by brass kettles. Rituals were influenced by the Jesuit and other Christian missionaries, who sought to change the native belief system.

The enormous growth of the Iroquois resulted in the emergence of five distinct tribes which, in 1530, formed the League of the Five Nations. The area in which Fulton is today was under the control of the strongest of the nations, the Onondagas. The Onondagas lived in the Syracuse area permanently and used the Oswego River for transportation. They had mostly seasonal camps, used for fishing and hunting, near the Oswego Falls, which they called Kagnewagrage, meaning "ledge over which water falls."

The Onondagas took back to their winter quarters several varieties of nuts and dried berries, and syrup tapped from maple trees. Fish and eels that were caught were dried and smoked for preservation. They also hunted deer and bear with the bow and arrow, both in the winter and the summer.

Around this time, the Seneca tribe of the Iroquois nation was attempting to expand its holdings. The Senecas made war on some of the Indians allied with the French, robbed some French traders, and even attacked a French Fort. As a result, the French crossed Lake Ontario in 1687 and burned Seneca villages. In 1688, 1,200 Iroquois Indians camped in what is now known as Fulton en route to attack the French in Montreal.

During this period, the war between the British and the French raged in Europe. Throughout the 75-year rivalry between the two countries for this region, activity centered along the waterways. This led the British colonists to encourage the Native Americans who were allied with them to send scalping parties against the settlements of their rivals: the French and those tribes allied with them. Between 1689 and 1763, this area played a prominent part during the Colonial wars, and it saw some of the greatest military expeditions known in America up to that time. On this side of the Atlantic Ocean, this war was known as the French and Indian War.

The following is a quote from a booklet published in 1978 in celebration of New York State's Oswego Canal (1828–1978), concerning the reason for Fulton's existence: "Historically, the portage necessitated by the thirty-nine foot drop at Oswego Falls, gave birth to the City of Fulton. Because the bateaux and canoes had to be carried around the falls for a distance of about one mile, it was only natural that a small settlement should develop at the site . . ."

The first permanent settler on the east side of the falls was Daniel Masters, a blacksmith by trade, who settled at the Upper Landing in 1793. He and his sons built a large cabin above the falls to provide food and shelter for travelers. They cleared a rough portage road along the trail, and, with an ox team, dragged boats and freight down to the Lower Landing, north of the rapids. Masters was known for the spearheads he made for those who wished to spear fish in the pools of water below the falls. He sold them for a silver dollar each.

Masters opened the first tavern in 1794 in the town of Volney. Later, in 1800, he and a man named Goodell built a sawmill. Later still, Masters moved north to what is now Sackets Harbor.

Following the Colonial period, local industries developed and remained in the Fulton area, using the waterpower available, as well as the canal-river for transportation of people and materials.

One

THE EARLY YEARS

The first white man to come to the falls of the Oswego River was a Jesuit missionary. The Oswego River (also known as the Onondaga River on some early maps) was the roadway for early soldiers, traders, and settlers passing from the Oneida Lake, Finger Lakes, and Syracuse areas to Lake Ontario at Oswego.

In July 1756, an English army officer, Colonel Bradstreet, passed through the area with 1,000 bateau men and 200 vessels carrying ammunition and supplies for the forts at Oswego. At Battle Island, which is located four miles north of Fulton, there was a skirmish between the French and Bradstreet's forces, with both sides claiming victory. After the battle, the British made plans for an army post to be built at the east end of the Oswego Falls. The earthworks of the original fort were destroyed in the early 1800s when the Oswego Canal was built and later when the Oswego Falls Corporation expanded its mills near the canal-river.

The falls of the Oswego River at the present Fulton site required a portage for travelers using the river. The only portages between Albany and Oswego were the one outside of Rome and the one at Oswego Falls. Two villages were eventually established, one on each side of the river, to assist in the portage and to house travelers.

HIGH BANKS. High banks is located just south of Fulton on the west side of the river near the mouth of Ox Creek. In the early days, this area was used for summer camps. Eventually, the camps were converted into year-round homes.

HIGH BANKS. All of the land on the west side of the river in the Fulton area was designated for use as military land grants by New York State. In lieu of pay, the grants were given to soldiers who fought in the militia during the Revolutionary War.

BRADDOCK'S COVE. This is one of many scenic views along the Oswego River.

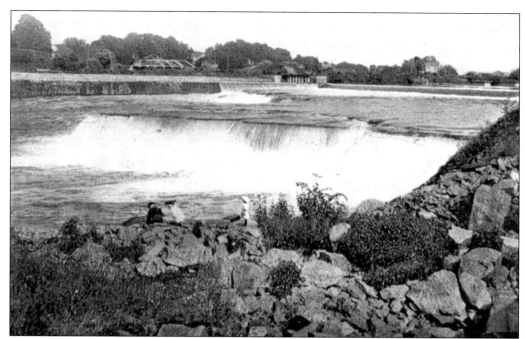

THE OSWEGO FALLS. The Native Americans called this area Quehok. It was a place where they had to carry their boats around the Great Oswego Falls, with its drop of 39 feet. The portage started at Yelverton Island, located south of the falls, and ended just north of the falls or farther down the river past the rapids.

SHOOTING THE FALLS. In the spring, when the water was high, daring boaters chose to "shoot the falls" to avoid the time-consuming portage. Yelverton Island was flooded when the dams were raised.

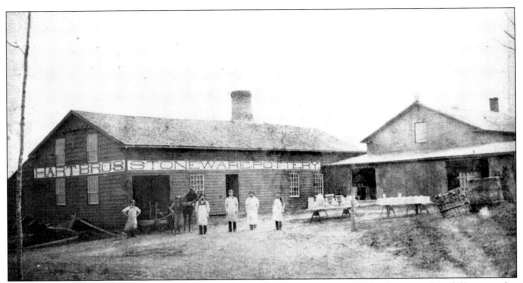

Hart Pottery. This is one of the early mills that was established near the falls to take advantage of the water. The Harts made stoneware for preserving food in the homes. Signed Hart pottery has great value today.

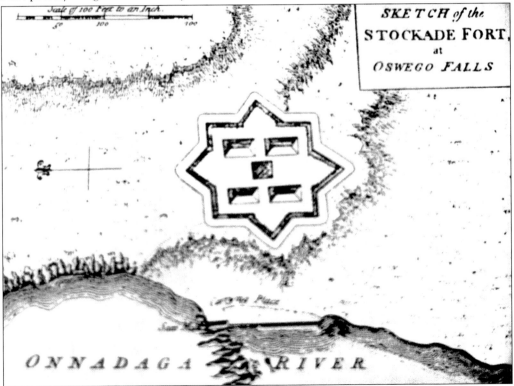

Fort Bradstreet. After Colonel Bradstreet fought at Battle Island, he saw the importance of the river. To defend the waterway, Fort Bradstreet was built at the Oswego Falls in 1758. A woman engineer designed this fort, as well as other forts that are similar.

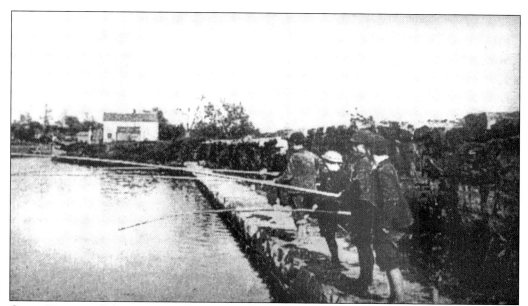

GOOD FISHING. Salmon swam up from Lake Ontario as far as the great falls to spawn. This picture was taken in the early 1900s. This area has always been a popular fishing spot, dating back to when spears were used.

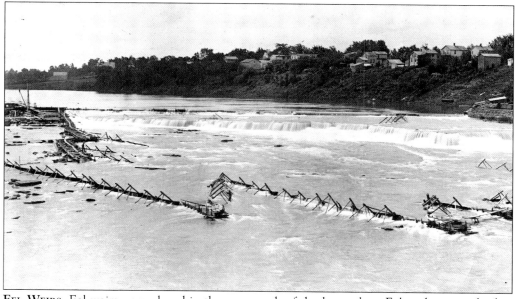

EEL WEIRS. Eel weirs were placed in the area north of the lower dam. Eels, salmon, and other fish— altogether worth thousands of dollars—were shipped to the cities along the waterway and to the East Coast.

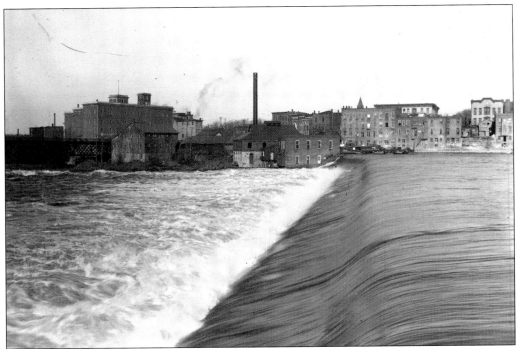

THE DAM. Raising the height of the dams provided more power for mills. The fishing industry suffered because the salmon no longer could swim upriver to the falls to spawn. However, the mills using waterpower flourished. This photograph was taken c. 1900.

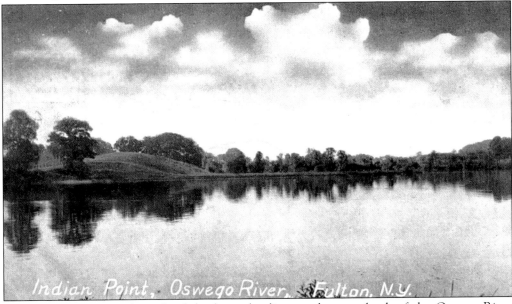

INDIAN POINT. Located north of the lower landing on the west bank of the Oswego River was one of the several spots that the Native Americans used as campgrounds for hunting and fishing, but it was not a permanent settlement. Artifacts have been found at this location that prove that they camped there.

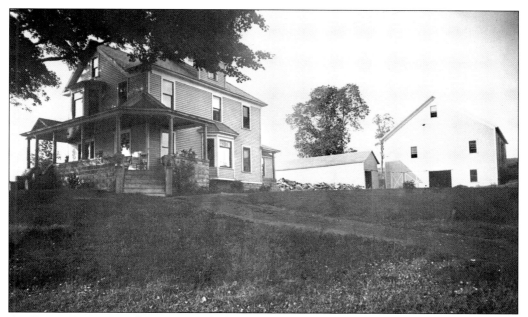

AN EARLY FARM. Seen here is an early farm that overlooked the river. The owners discovered that the gravel bed near the river provided them with a profitable business, and they farmed the land only for themselves.

PATHFINDER ISLAND. With its clubhouse and ball fields, Pathfinder Island was a playground for Fulton's elite. The island was named after a novel by James Fenimore Cooper, who had spent time in the area. People say that the present owner bought the island just because he always wanted to own an island.

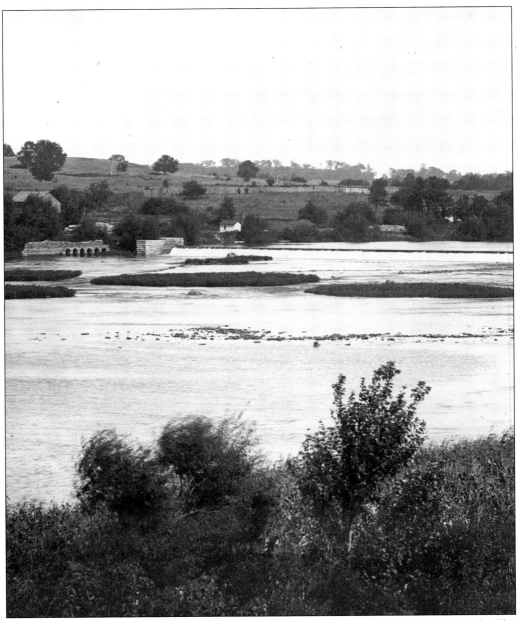

NORTH OF BATTLE ISLAND. The river looked much like this, with small islands and rapids. The settlers farmed along the river. The stone remains of the Oswego River Starch Company are visible in the background.

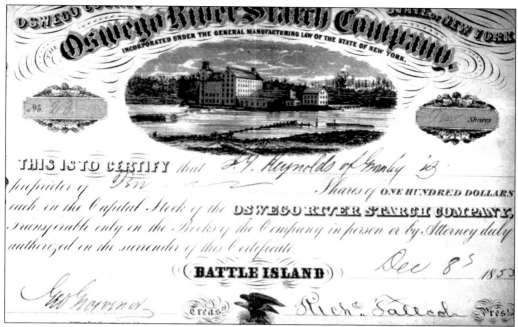

A Stock Certificate. The Oswego River Starch Company was located across the river from the Battle Island paper mill. The factory, which used the falls for waterpower, was destroyed by fire.

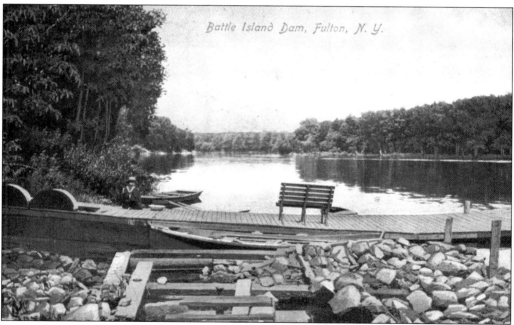

Battle Island. One of the best-known facts about Battle Island is that a battle was fought here during the French and Indian Wars. As the river was raised for the larger shipping boats, the island eventually got much smaller.

THE VAN BUREN HOME. Early settlers built their homes facing the river. This one was the home of the the Van Burens, who were among the first to house travelers along the river. They were relatives of Pres. Martin Van Buren.

Two

THE ERIE CANAL INFLUENCE

No sooner had the Erie Canal been built than the Oswego Branch was started. The actual construction started with the building of the first lock at the lower landing on July 4, 1826. The work ended in December 1828. Many bridges had to be built over the hand-dug canal. There were 38 miles of canals made of stone and timber connecting the river by locks and dams. There were 13 locks with a total lift of 123 feet and one aqueduct in Fulton at Waterhouse Creek. Also, there were 18.5 miles of slack-water navigation, and convenient towpaths along the river. The canal had 22 towpaths with bridges, 7 culverts, 2 waste weirs and 8 dams.

People had the opportunity to choose either fork in Syracuse: the north branch or the east and west branch. The north fork to Oswego saved two days of travel time and it was cheaper for travelers going west.

The state decided not to charge a fare for cords of wood for the purpose of making salt in the town of Salina. Consequently, the canal did not make much money the first year. It did not take long for the Oswego Branch to make more money than the Buffalo Branch. There was soon a need to enlarge the branch, a process that occurred several times.

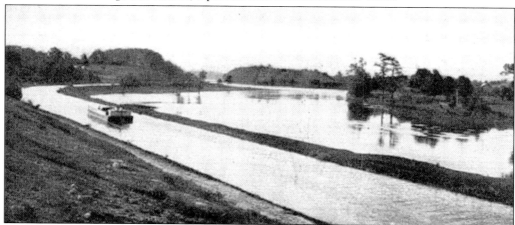

NORTH OF FULTON. This is the Oswego River and the canal between Oswego and Fulton. The canal boat is heading for Fulton. One legend of the naming of Fulton is that coal barge operators, when calling out how much coal they had for sale, usually shouted, "Full ton." However, the name Fulton was suggested at the laying of the cornerstone for the first lock because inventor Robert Fulton had recently developed the first practical steamboat.

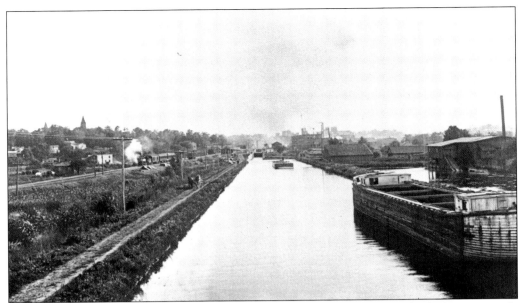

THE ENLARGED CANAL. Due to increased use, between 1847 and 1862, the locks were made larger and the canal bed was made wider and deeper. These barges are heading into the mill district from the north. Note the horses pulling the canal boat on the left side of the picture.

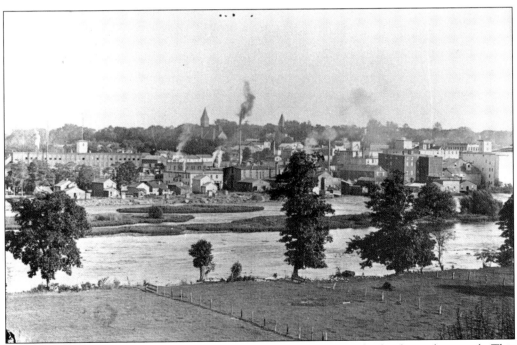

FULTON'S EAST SIDE. Seen here are the many mills that were built along the canal. This photograph was taken at the height of the manufacturing era. First came the sawmills, then the flour mills, and, later, the paper mills and others.

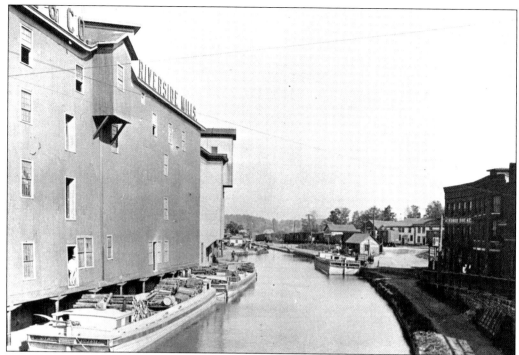

LOOKING NORTHWARD. Seen here are the mills along the inland area of the canal. At the north end of Fulton, the canal extended about two blocks inland and then northward, close to where Route 481 is today.

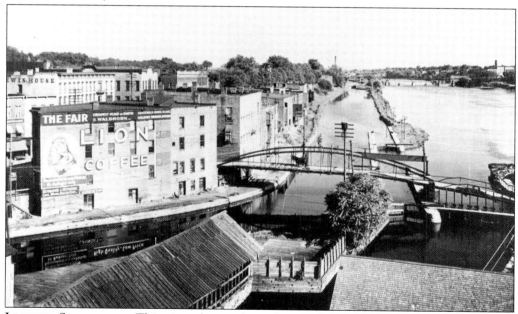

LOOKING SOUTHWARD. This view shows where the canal turned inland for many blocks to facilitate shipping of merchandise from the many mills in the northern part of town. The boats accommodated the mills on both sides of the canal.

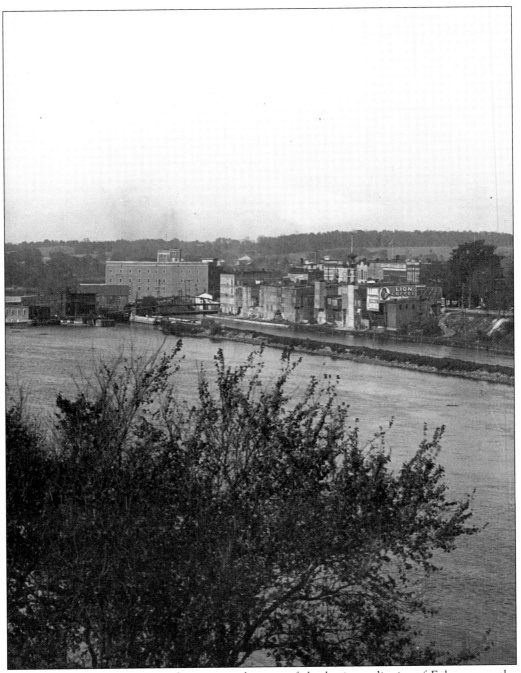

THE EARLY BUSINESS AREA. This is an early view of the business district of Fulton near the Lower Bridge. This is a good view of the river, canal, towpath, and First Street, located between the two bridges.

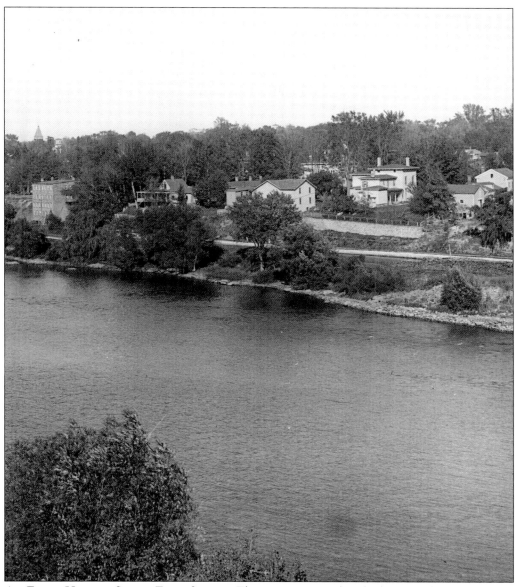

AN EARLY VIEW OF SOUTH FIRST STREET. This picture was taken looking northward from the Broadway Bridge. The three-story building was a hotel for canallers. It was made out of the stone that was quarried here. In later years it was replaced by the Fulton Public Library.

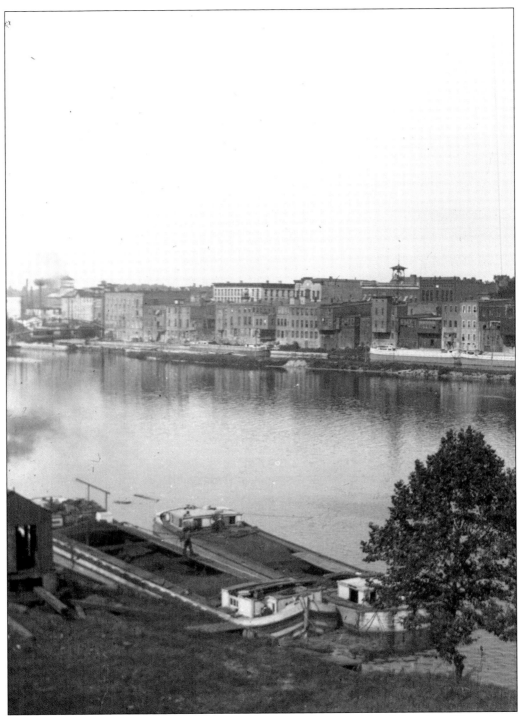

LOOKING EASTWARD. You can see two canal boats on the west side of the river. These boats probably unloaded coal for the Woolen Mills. There were several coal piles stored in this area.

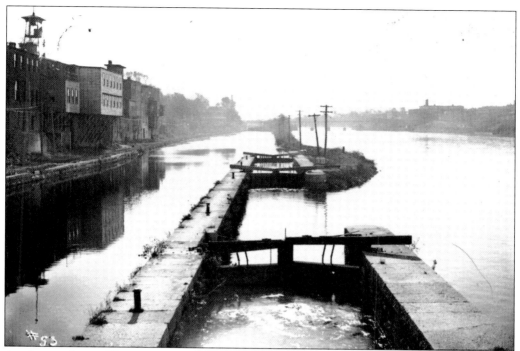

AN ACCESS LOCK. This view was taken looking southward from the east side. It shows the area where the canal boats can get into the river and pole across to the west bank. The gates were opened and closed by hand.

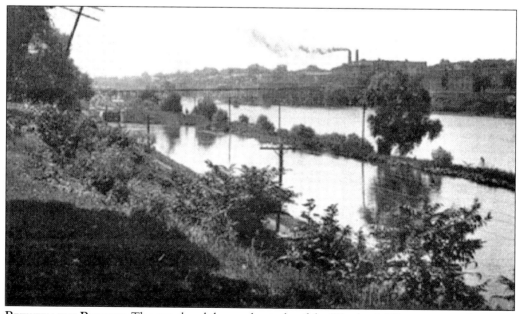

BETWEEN THE BRIDGES. The canal and the smokestacks of the Woolen Mills are seen in this view. It was many years later that the areas between the Upper and Lower Falls were developed.

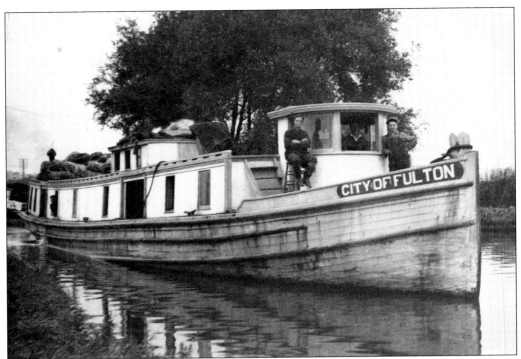

THE CITY OF FULTON. The tugboats carried both passengers and cargo. They had to go slowly so that the wake they caused would not erode the dirt sides of the Oswego Canal.

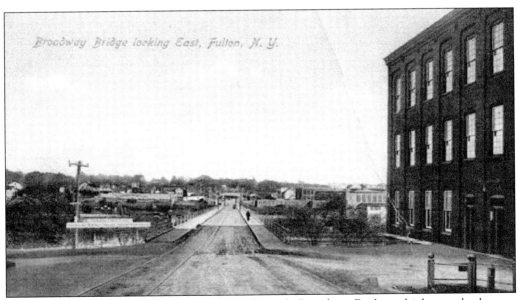

THE BROADWAY BRIDGE. This picture shows the early Broadway Bridge, which was also known as the Upper Bridge. The bridge has been replaced several times.

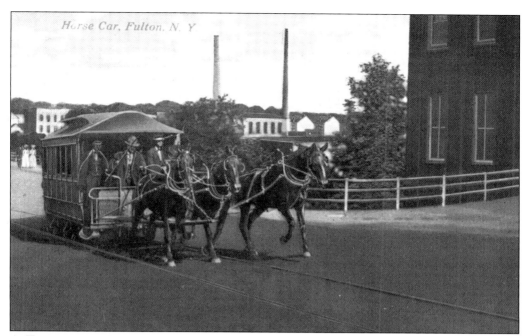

A TROLLEY. On the Upper Bridge is the horse-drawn trolley that took passengers from the Lewis Hotel to the Delaware, Lackawanna & Western train station and fairgrounds c. 1900.

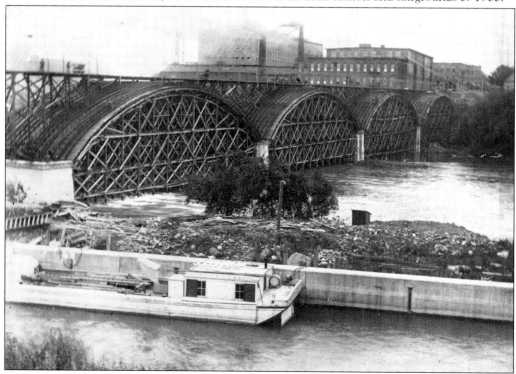

THE BROADWAY BRIDGE AND THE CANAL. The bridge is being rebuilt to handle increasing traffic. This old canal boat in the foreground was soon to be replaced by larger boats.

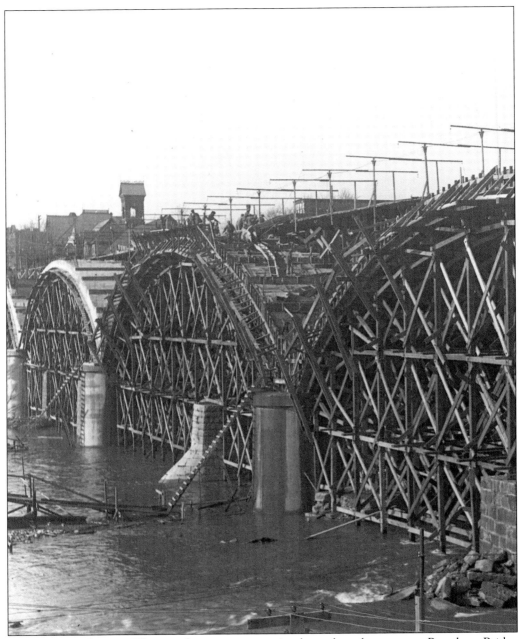

BUILDING THE BRIDGE. This wooden structure was in place when the concrete Broadway Bridge was built. That concrete bridge has since been replaced with a new modern bridge. Note the bell tower on the Congregational church, which was located on West Broadway. The tower has since been removed.

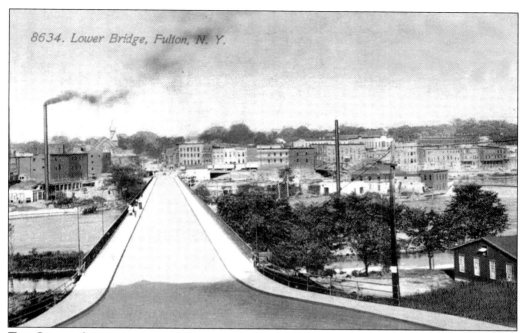

THE ONEIDA STREET BRIDGE. Bridges were built and rebuilt to connect both sides of the river. This is the Oneida Street Bridge, which passes over both the power plant raceway and the river c. 1900. The first bridge was almost at water level.

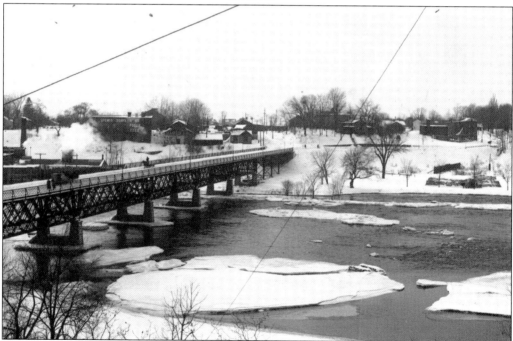

THE LOWER BRIDGE. Here is an earlier view of the Oneida Street bridge in winter. In the 1800s, when a major fire struck the east-side business district, residents of the west side sawed the wooden bridge in half to keep the fire from spreading across to their neighborhood.

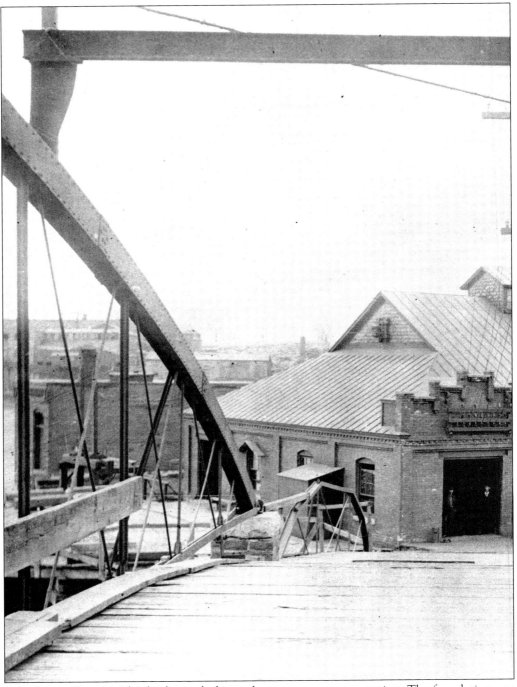
THE CANAL BRIDGE. This bridge took the workers over to a power station. The foundation was made of limestone that dated to 1880. At this location, power was generated by a waterwheel.

Three

BUILDING THE BARGE CANAL

The Barge Canal was the second major enlargement of the New York State canal system known as the Erie Canal. The canal was moved north of Syracuse to take advantage of Oneida Lake and the Seneca River. The Oswego Branch started at Three Rivers and was a part of the river all the way to Lake Ontario. Seven locks are included in the system..

The Barge Canal was a minimum of 12 feet deep and 75 feet wide. The locks were eventually 325 feet long, 28 feet wide, and 12 feet deep. Wickets that are located just south of the dam at Oswego Falls control the water level. In the Fulton area, the work was done between 1904 and 1908. The area at Oneida and First Street was disrupted by the work. The old canal that went through Fulton was filled in when the Barge Canal was completed .

The Barge Canal did fairly well until the St. Lawrence Seaway was built. Then, shipping decreased drastically. However, in recent years, recreational use of the canal has grown.

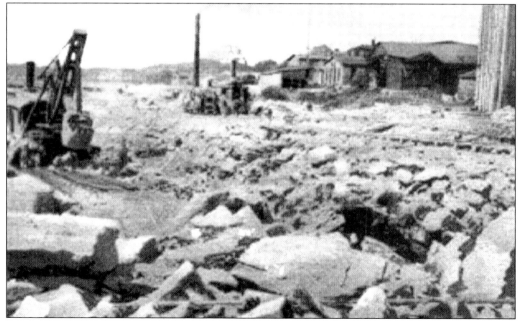

MAKING THE CANAL. This view shows the Barge Canal in Fulton as it is being built. In making the canal, many stones were removed from the riverbed.

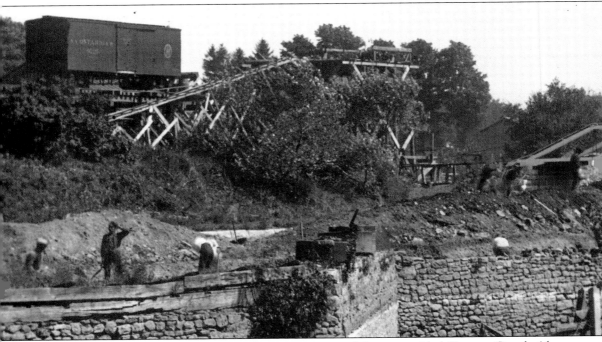

THE OSWEGO CANAL. Seen here is the construction of the stone-sided Oswego Canal. Also seen is one of the railroads that was built to make it easier to transport materials. The men are

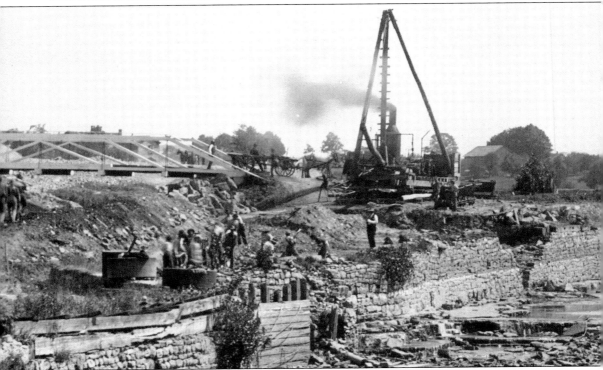

THE COFFER DAM. One of first things to be done was to divert the flow of the water from the

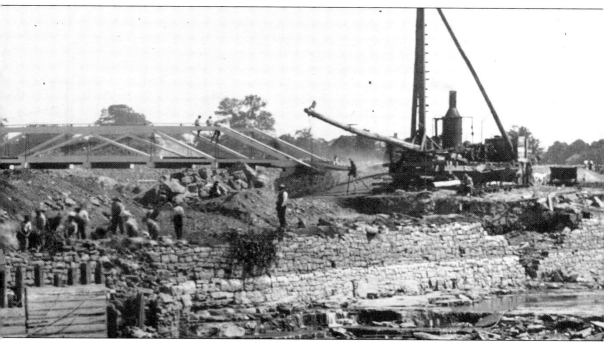

working in the lock area, and the wall of the old Oswego Canal is separating them from the river.

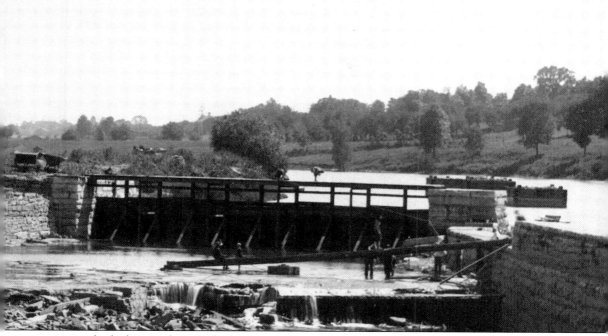

area in which the canal was to be built. The stone wall from the old canal is on the left.

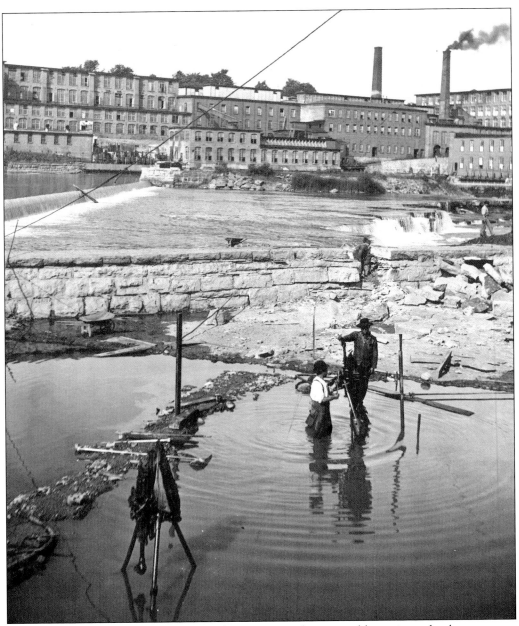

AN EARLY PICTURE. After diverting the water, workmen could get into the bottom area to survey. The men appear to be shoveling mud.

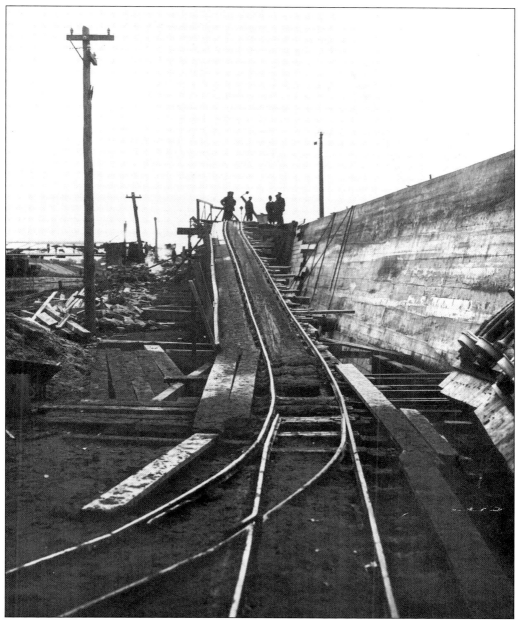

TEMPORARY TRACKS. Temporary railroad tracks were built down to the bed of the canal so that debris could be easily removed. Tracks were laid along the bed of the canal.

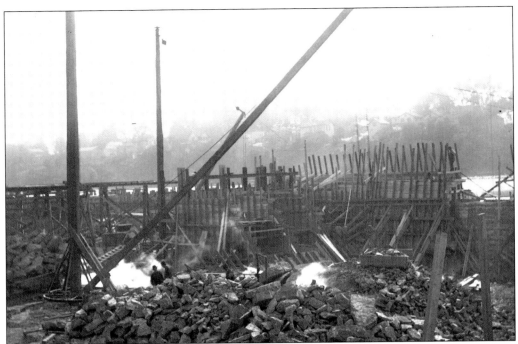

BUILDING THE COFFERS. This image shows a cofferdam that has been completed. These dams were used to empty some of the water in the river so that workmen could reach the riverbed.

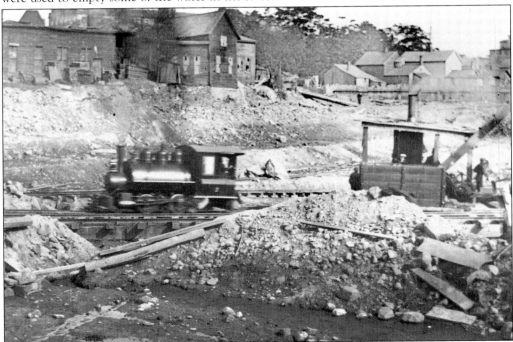

A DONKEY ENGINE. This photograph shows a small engine, called a donkey, working on the canal. These engines pulled a lot of dirt, stones, iron, wood, and cement during the construction of the canal.

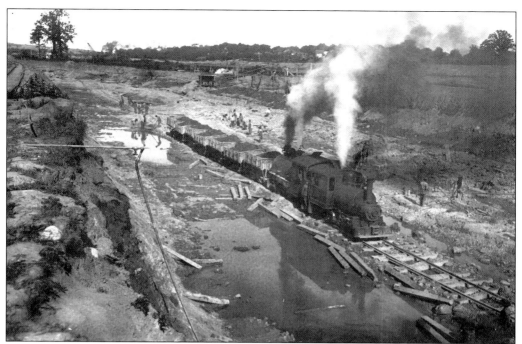

Two Donkey Engines. Two engines hitched together could easily pull several cars full of debris. The pair of engines are hauling the debris away to prepare the canal bed.

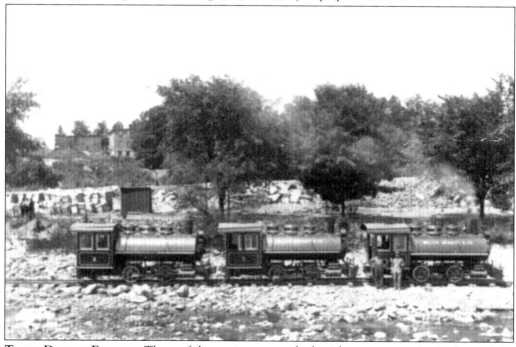

Three Donkey Engines. Three of the engines are parked, with two men posing in front of the first one. The donkey engines put in long hours while the riverbed was being deepened and the lock areas were being built.

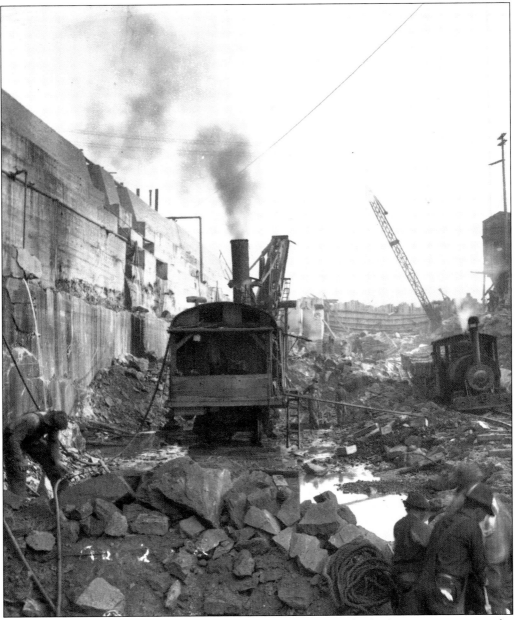

THE BED OF A LOCK. Working in an area where a lock is to be built are an engine and a steam shovel.

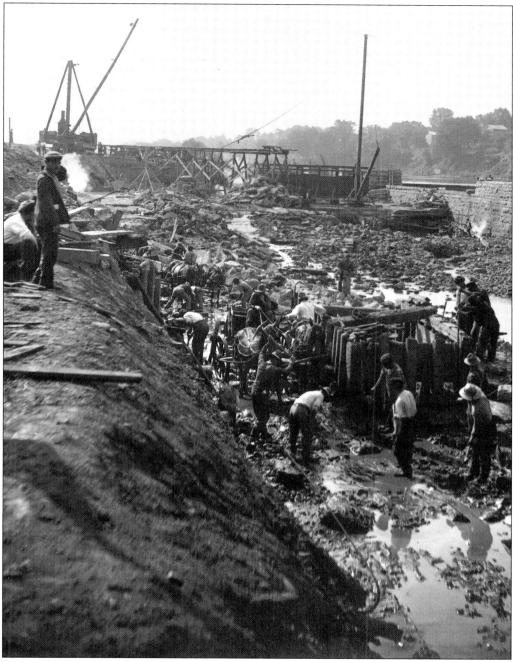

CONSTRUCTION WORK. The people of Fulton found the construction of the Barge Canal fascinating. Many came to observe the progress and to take pictures.

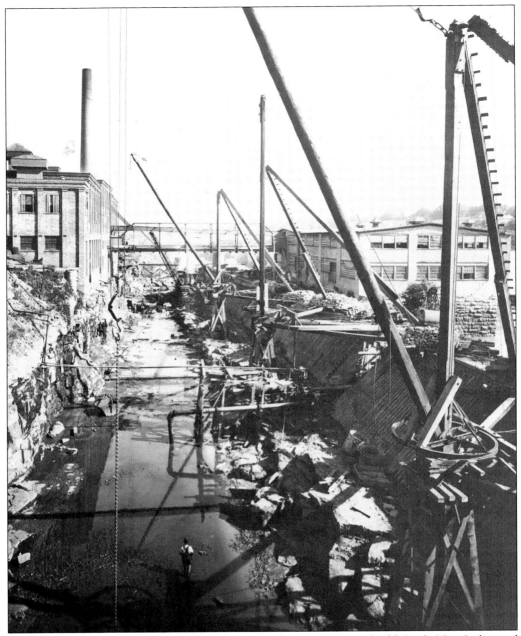

THE BARGE CANAL. Utilizing many cranes, workers prepare to build Lock No. 2, located between Oswego Falls Pulp and Paper Company and the power station. Note the footbridge between the buildings in the background.

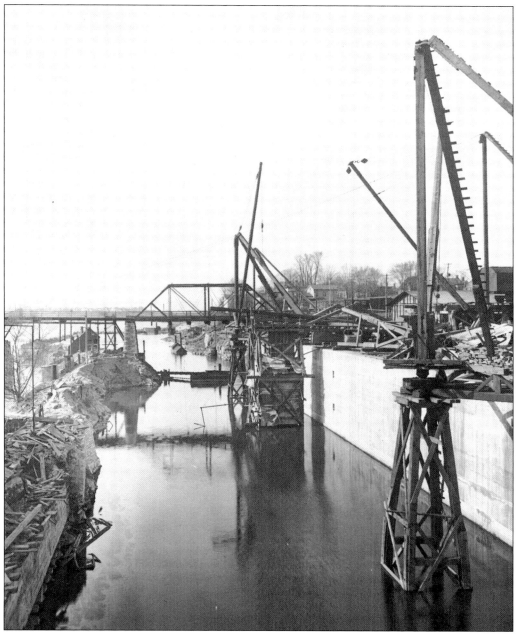

ONE SIDE. One side of the lock is in place. This view was taken looking northward toward the Broadway Bridge.

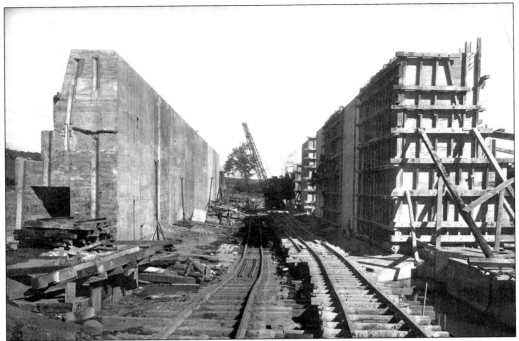

THE FRONT OF LOCK. Two sides of the lock are almost completed. Notice the amount of debris along the tracks.

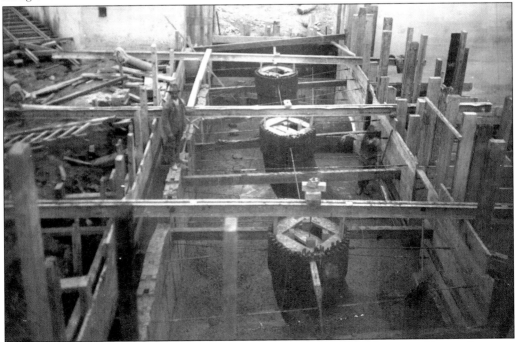

GRAVITY FEED. Pipe systems located at the bottom of the locks helped raise and lower the water level by gravity; pumps did not need to be used. Most people think that locks simply fill up when the doors open.

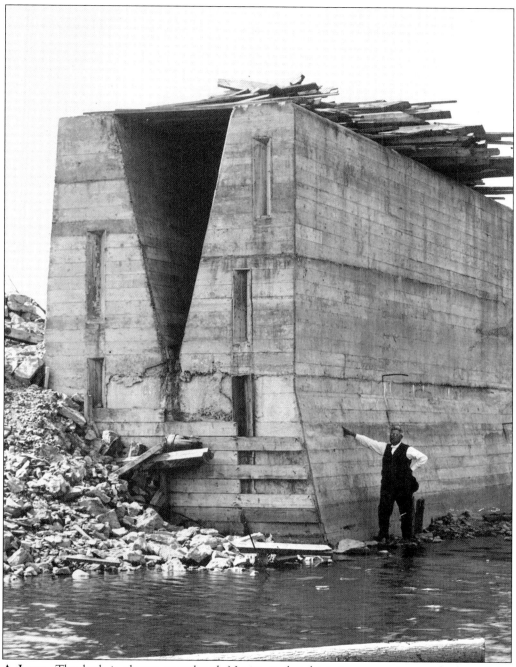

A Lock. The lock is almost completed. Notice its height is in comparison with that of the man.

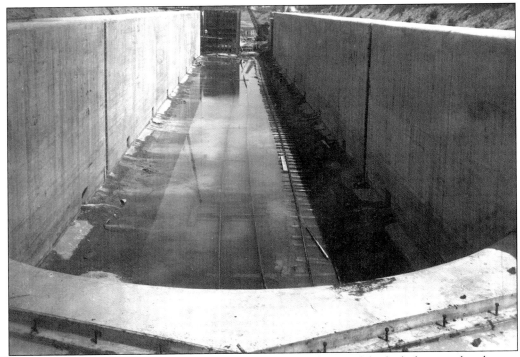
THE SILL. The sill goes under the lock door. At the far end, one of the lock doors is already on.

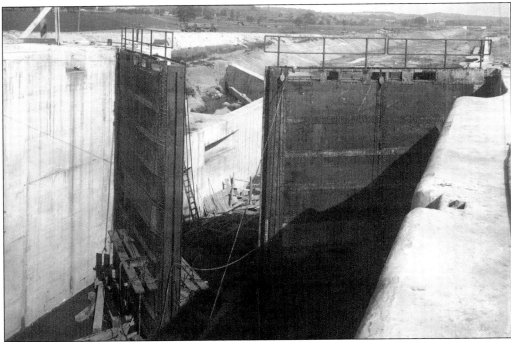
THE GATES. Two lock gates are now in place. Notice the area in the wall cut back to allow the open gates to fit flush when open.

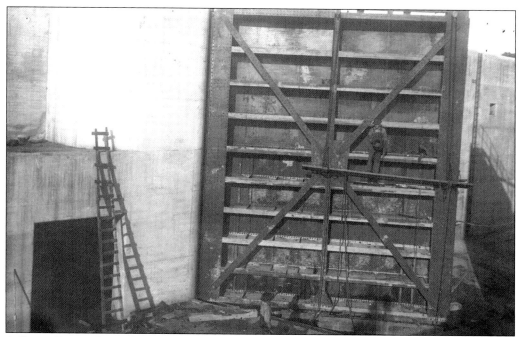

A STEEL DOOR. One of the steel doors of the lock is in place. This image provides a good view of the construction of the door.

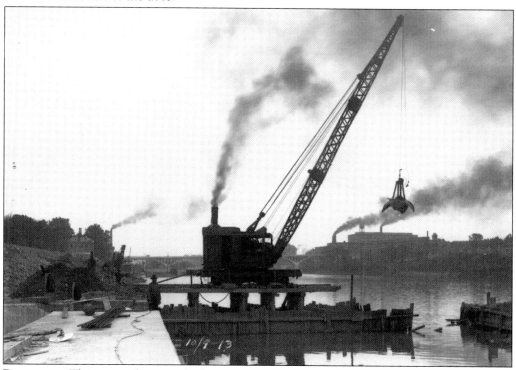

DREDGING. This view shows a dredging operation on a temporary trestle along the canal between the bridges. The river was dredged to accommodate the barges.

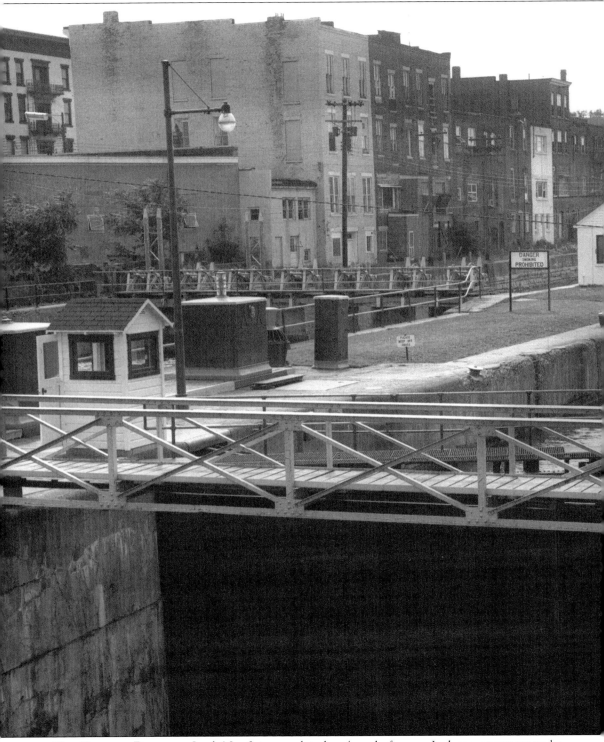

THE FINISHED PRODUCT. Lock No. 3 is completed and ready for use. It does not appear to be

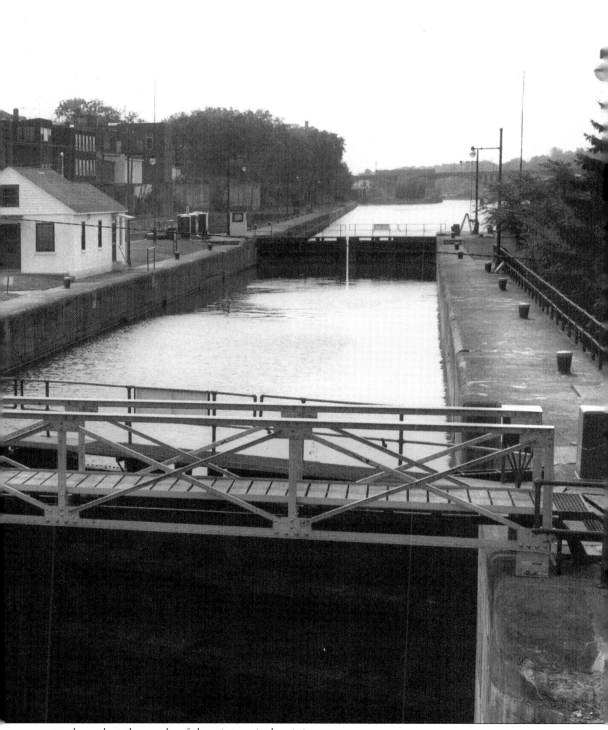
very long, but the angle of the picture is deceiving.

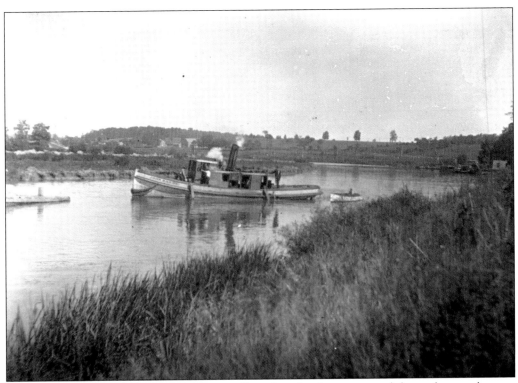

AN EARLY TUGBOAT. This early tugboat pulls and pushes barges up and down the canal.

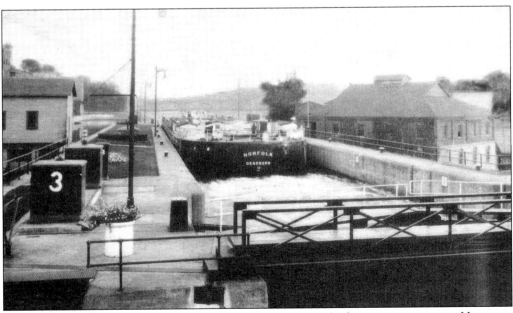

LOCKED IN. A self-contained barge uses the lock. This barge had its own power unit. However, tugboats were used, also.

Four

STREETS AND BUILDINGS

Historically, the settlement on either end of the Great Oswego Falls, was called Oswego Falls. Eventually, Oswego Falls expanded to include the settlement at the northern end of the west side of the river. The area at the lower landing on the northeast side of the river became the village of Fulton, named at the dedication of the first lock by one of the speakers, Judge Brewster of Oswego. The canal was to become the lifeblood of the area and was as beneficial as inventor Robert Fulton's first profitable steamboat.

In the early 1850s, the whole east side became the village of Fulton, and the village on the west side of the river remained Oswego Falls. It was not until 1902 that the two villages combined to form the city of Fulton. The portage on both sides of the river became First Street both in Oswego Falls and Fulton. First Street in Fulton on the east side was called Portage Road.

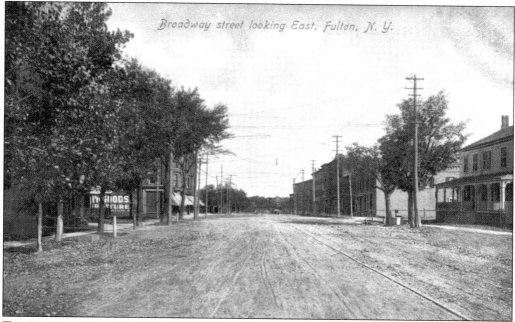

THE WEST SIDE. The shopping area on the west side is the only business district in the city that has not undergone major changes. This view looks eastward past Second Street toward the Broadway Bridge.

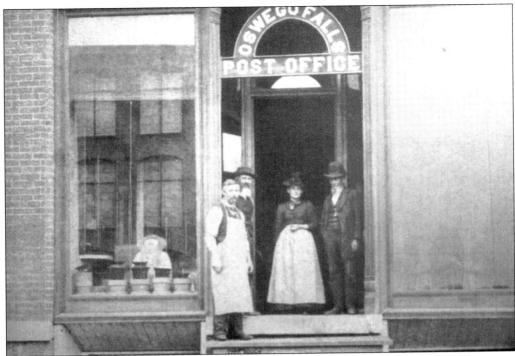

THE POST OFFICE. Prior to 1902, the Oswego Falls Post Office was on the west side of the river.

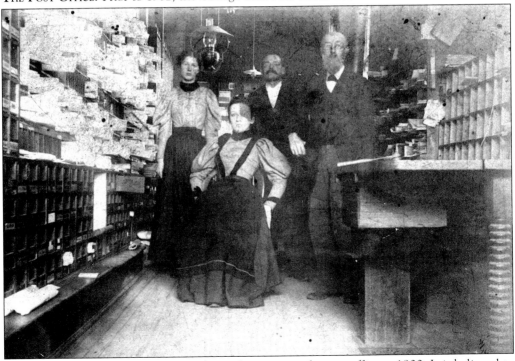

INSIDE THE POST OFFICE. This view shows the interior of a post office c. 1900. It is believed to be the Oswego Falls Post Office.

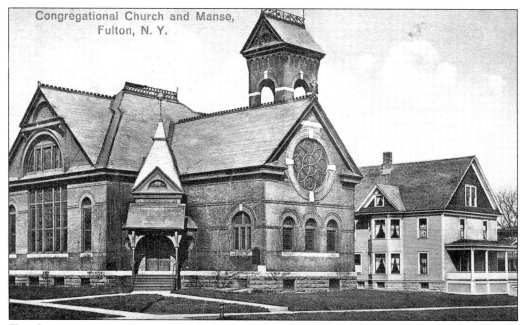

THE CONGREGATIONAL CHURCH. The Congregational church, built in 1882, was the first church organized in the village of Oswego Falls. It was located at West First Street and Broadway. Note the bell tower, now removed.

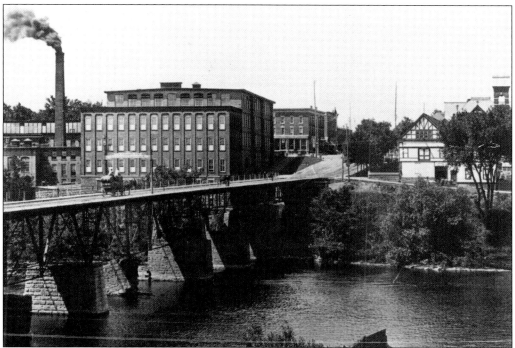

THE MILL AND THE HOUSE. The house on the west side at the end of the Broadway Bridge was used to feed the American Woolen Mills workers. The mill is located on the left side of the bridge.

WEST FIRST STREET. In the early days, most workers walked to the mill. The American Woolen Mills Company built small homes to rent to its employees. These homes are located on the right side of West First Street, just north of the West Broadway intersection. One row of houses faced the street and another row faced the river. Eventually, the renters were offered the opportunity to purchase these homes.

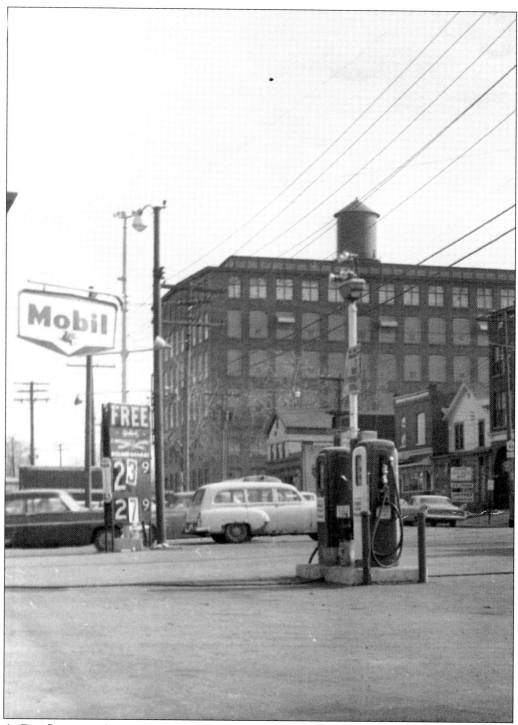

A Gas Station. A gas station was located on each end of the Broadway Bridge. This Mobil station is on the west side. One of the American Woolen Mills buildings is in the background.

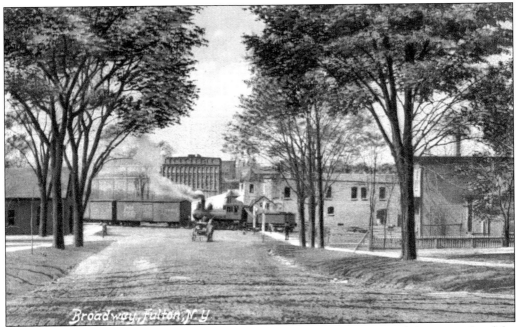

EAST BROADWAY. This view looks westward from East Third Street toward the west side of the river. The American Woolen Mills is in the background. The train is traveling down South Second Street.

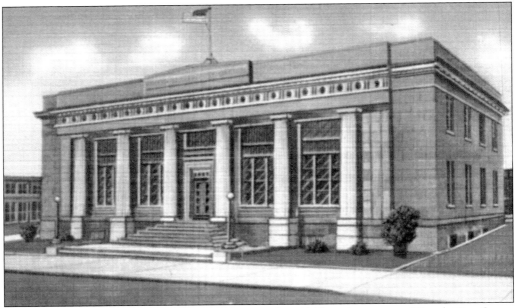

THE POST OFFICE. The post office was constructed in 1915 at the corner of South First Street and East Broadway. With the exception of the lights in front, it looks very much the same today. The building is listed on the National Register of Historic Places.

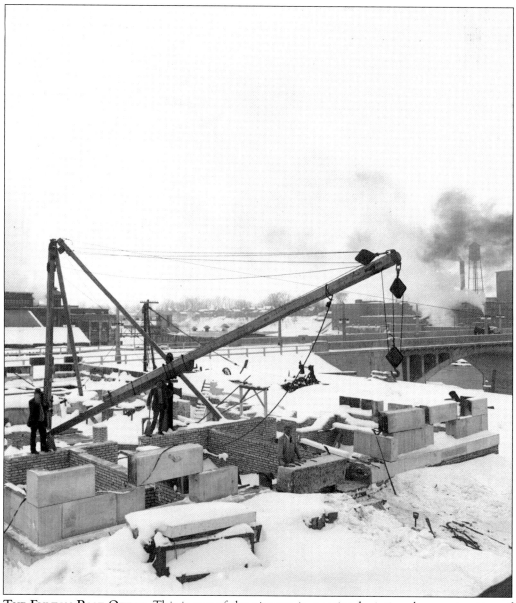

THE FULTON POST OFFICE. This is one of the pictures in a series depicting the construction of the Fulton Post Office. The post office displays a mural depicting Father Le Moyne in a canoe in the Oswego River, with his arms outstretched to Native Americans on Pathfinder Island.

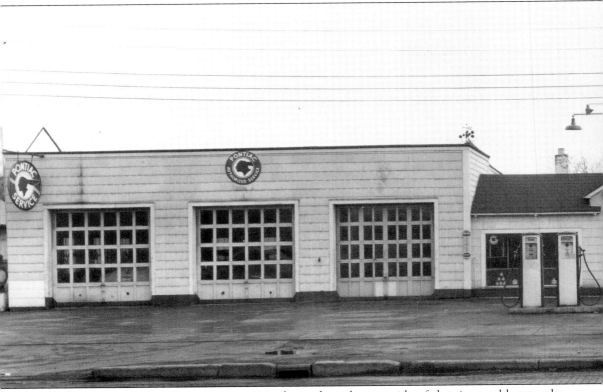

A SERVICE STATION. This service station, located on the east side of the river, sold not only

THE SMALL BUSINESS DISTRICT. This view of the corner of East Broadway and South First Street shows the small shopping area that existed before the post office was built across the

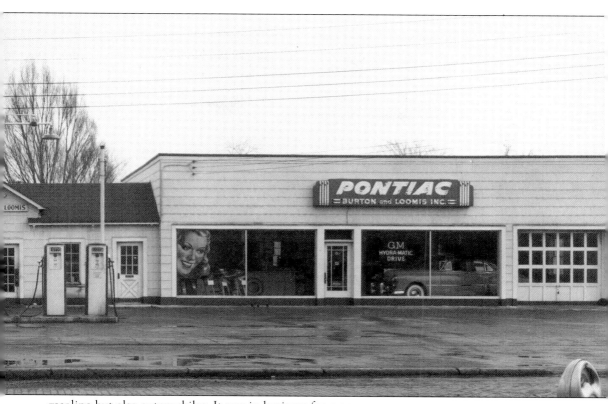
gasoline but also automobiles. It was in business for many years.

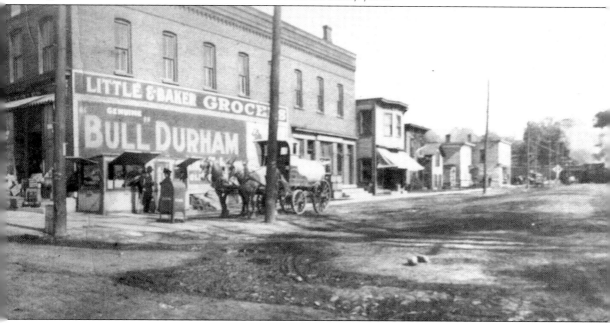
street. The small business district still exists, but the types of stores have changed since the early 1900s.

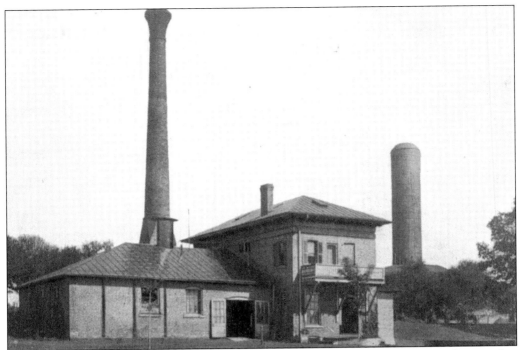

GREAT BEAR SPRINGS. Located south of Fulton, Great Bear Springs produced excellent quality bottled water that was sold throughout the Northeast for many years. The Fulton city water facility is now located in this area, on the east side of the river.

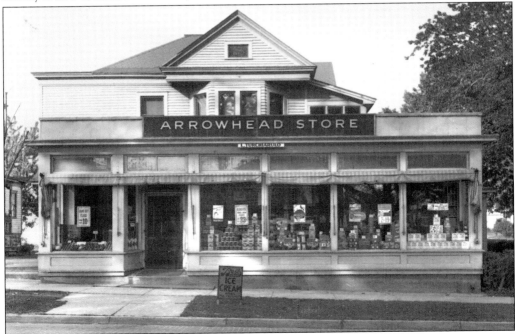

THE NEIGHBORHOOD STORE. Arrowhead Store was a neighborhood store located just south of East Broadway. It was a little larger than the typical neighborhood stores.

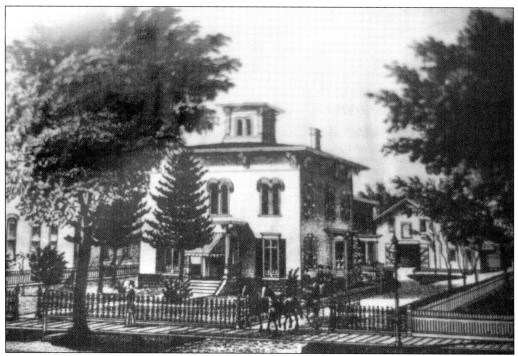

THE PRATT HOUSE. Built in 1863 in the Italianate style, this house is now referred to as the John Wells Pratt House. It is the present location of the museum operated by the Friends of History in Fulton, New York, Inc.

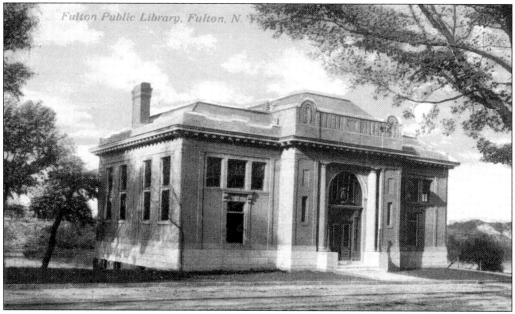

THE LIBRARY. When Falley Seminary closed, its library books were used to start the Fulton Public Library, which at the time was located above a store on South First Street. Later, philanthropist Andrew Carnegie donated money to build this new library on South First Street.

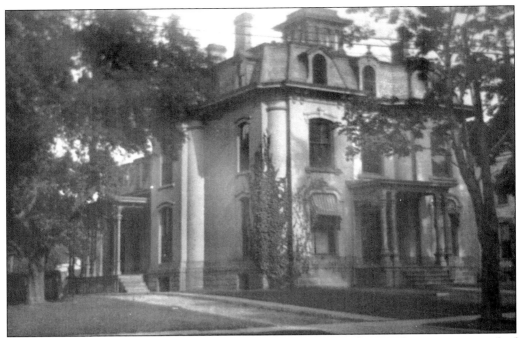

THE HUNTER HOUSE. The Hunter house, located at 173 South First Street, was typical of the affluent homes built on South First Street in the mid- to late 1800s by Fulton's wealthy businessmen. This home and many of the others have been demolished for urban renewal.

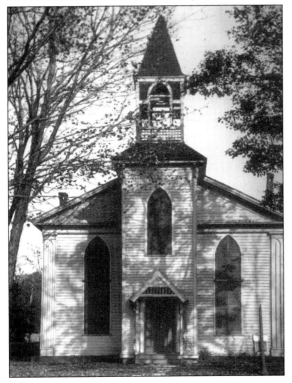

ALL SAINTS EPISCOPAL CHURCH. The Zion church was organized in 1835 and its building consecrated in 1843. The Granby and Fulton Episcopal Churches united, and a new edifice replaced this wooden structure, on the corner of South First and Academy Streets.

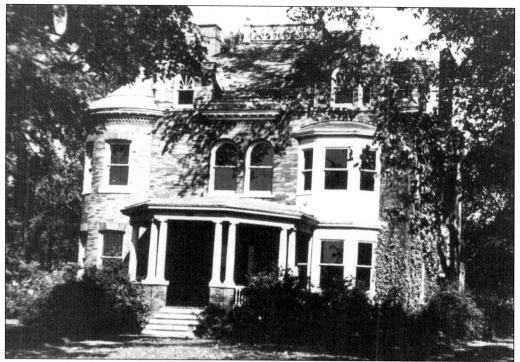

THE OSBORN HOUSE. The Osborn house was located at 139 South First Street. This beautiful home was used by several physicians as an office. It was torn down to make room for the new municipal building.

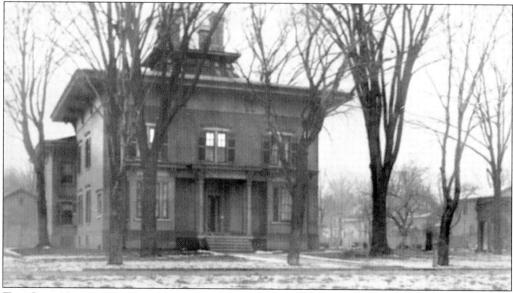

THE CASE HOUSE. The Case house, located at 133 South First Street, was owned by abolitionist Charles G. Case, who was active in the Underground Railroad. Escaped slaves were likely sheltered here. In later years the house was purchased by the Elks Club, whose members added a large wing in the back and increased the size of the porch.

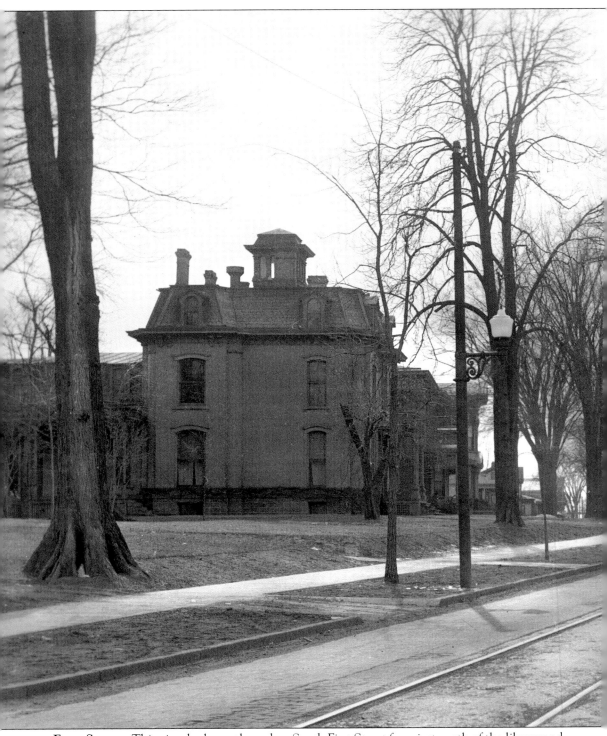

FIRST STREET. This view looks southward on South First Street from just north of the library and the Hunter house. The library, on the right, is located on the site of a former stone quarry. Stone

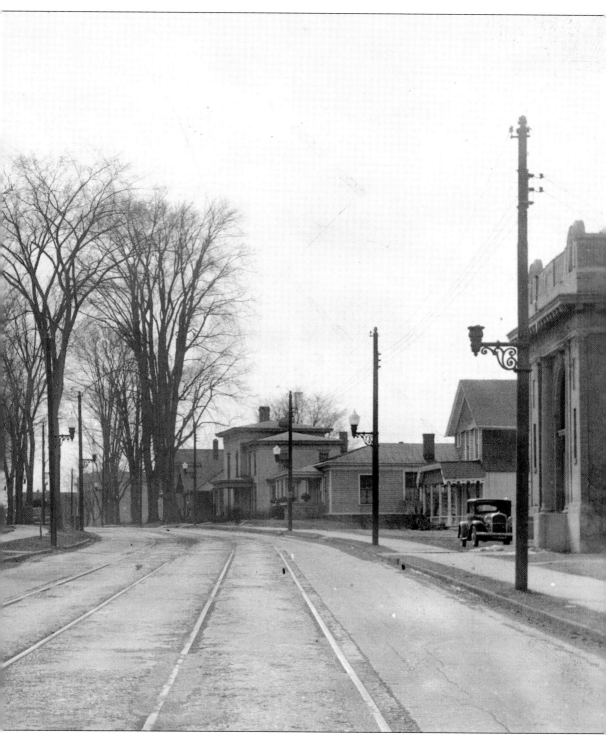
from that quarry was used to build the Auburn Prison and some of the brownstone buildings in New York City. The trolley tracks went from Syracuse, through Fulton, to Oswego.

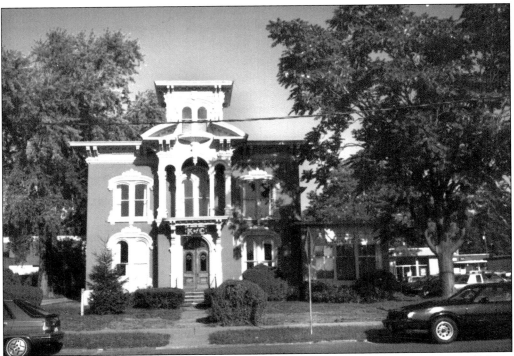

THE GARDNER HOUSE. The Gardners honeymooned in Spain and, upon returning to Fulton, included features of Spanish architecture in the construction of their new home at 45 South First Street. The house later became the home of the Citizens Club and, later still, the home of the Knights of Columbus.

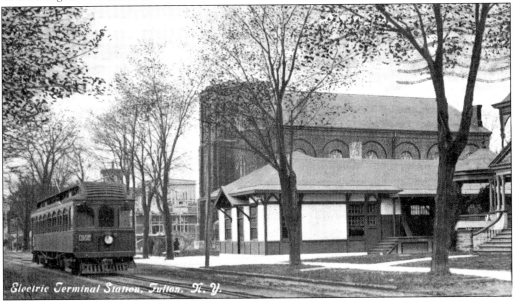

THE TROLLEY STATION. The electric trolley station was on South First Street. The trolley route ran from Oswego through Fulton to Syracuse and was a popular mode of transportation prior to the widespread use of automobiles and buses.

THE UNIVERSALIST CHURCH. The Universalist church was built in 1864. The building was replaced with the Quirk Theater, which seated 1,200 people. The theater became a movie house and, today, it is Towpath Towers, apartments for senior citizens.

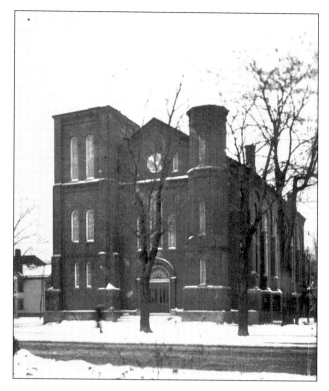

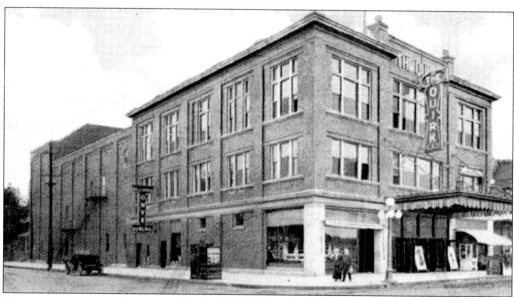

THE QUIRK THEATER. The Quirk Theater opened its door on February 17, 1913, at First and Rochester Streets. The theater had a bowling alley and a billiard parlor in the basement and a jewelry store and an ice-cream parlor on the ground floor. The theater was known for showing plays with well-known actors and actresses and for hosting the first live radio broadcast in the area. The first talkies were shown there in 1929.

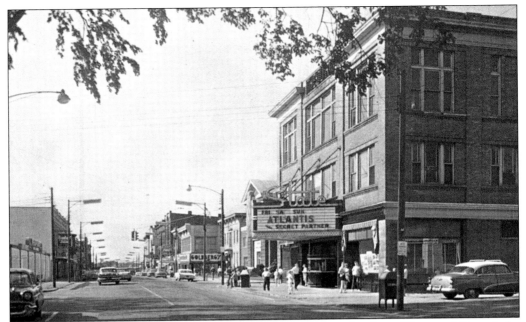

THE STATE THEATER. As motion pictures became popular, the State Theater followed the Quirk Theater. The theater building had offices on the second floor and the Masonic Hall on the third floor.

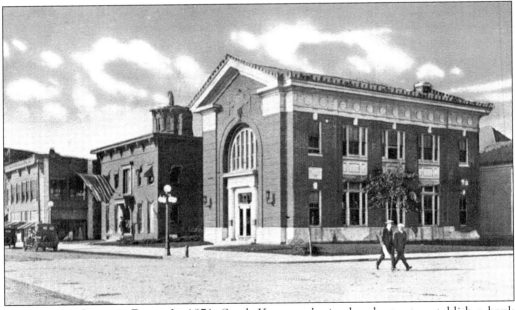

THE FULTON SAVINGS BANK. In 1871, Sands Kenyon obtained a charter to establish a bank and, in 1911, this building was erected at South First and Rochester Streets. The Fulton Savings Bank is still in business today and has several branches.

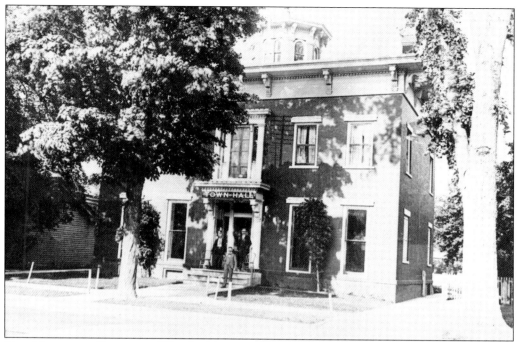

THE MUNICIPAL BUILDING. This building was the town hall of Volney. In 1902, it became Fulton City Hall, which was later torn down. The site now serves as the Fulton Savings Bank's drive-through banking, plus a very small park.

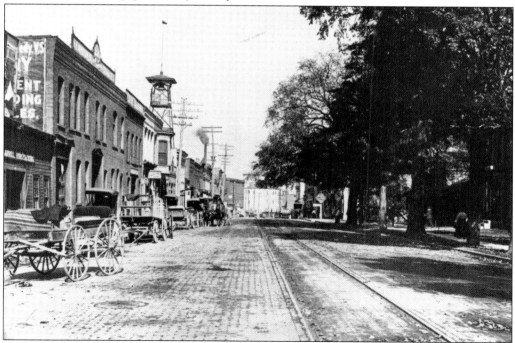

SOUTH FIRST STREET. From just below Rochester Street, this c. 1900 view looks north. The firehouse and its landmark bell tower are visible.

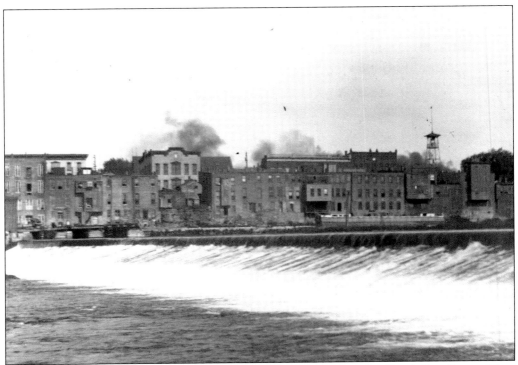

THE RIVER SIDE. This scene shows the river side of businesses that face South First Street. Note the canal boats tied up along the Oswego Canal.

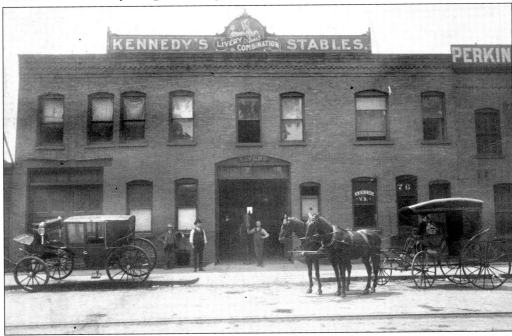

A LIVERY. Next to the firehouse was a livery, which was an important service in the horse-and-buggy days.

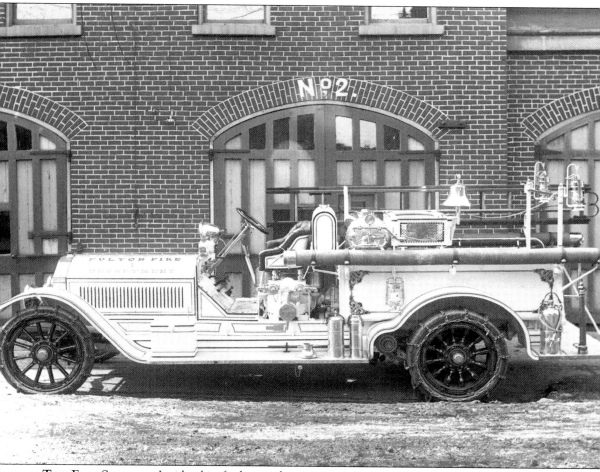

THE FIRE STATION. Inside this firehouse, harnesses were suspended above the horse stalls. When the alarm sounded, the harnesses were dropped onto the horses, which then hauled the firefighters and their equipment to the fire scene. Even after modern fire trucks were purchased, the harnesses were left hanging up. Eventually, the building was demolished. Today there are two fire stations, one on each side of the river.

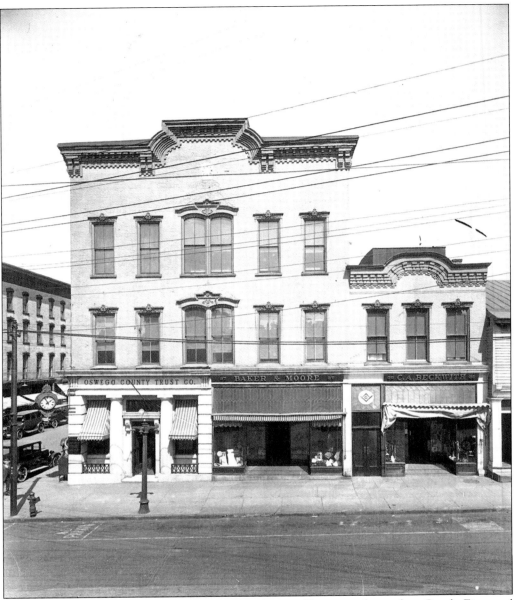

THE OSWEGO COUNTY TRUST. The Oswego County Trust was located at South First and Cayuga Streets. When the bank burned, the vault withstood the fire. The clock, seen at the left, was a local landmark, which is still missed today.

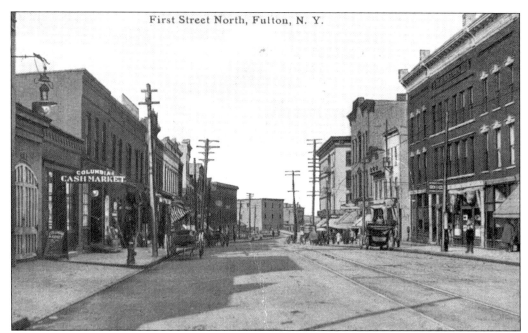

SOUTH FIRST STREET. This view looks north from just past the fire station. Notice the "Cash Market" sign. In the early 1900s, many stores gave credit to customers and delivered groceries to the customer's homes.

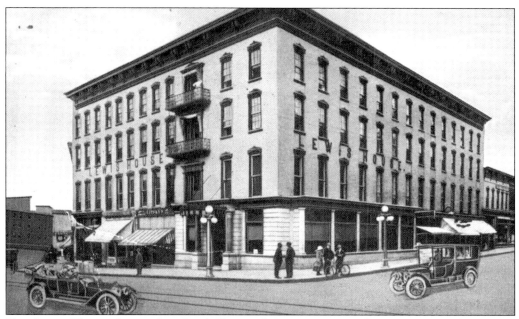

THE LEWIS HOUSE. Located at South First and Cayuga Streets, the Lewis House began as a temperance hotel. Later, the second floor of the building was used for meetings and dances. The entrance to the second floor was from the building next door. The hotel had stores on the ground floor.

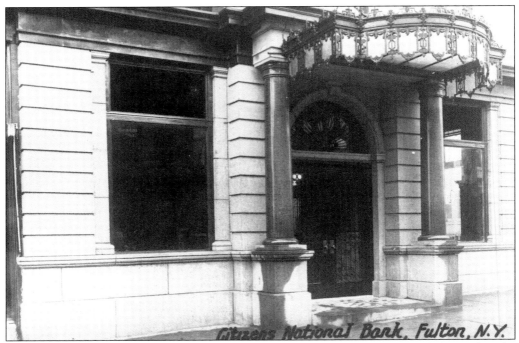

THE CITIZENS NATIONAL BANK. In 1830, Sands Kenyon opened a private bank located in the Lewis House building. In 1854, it became the Citizens National Bank.

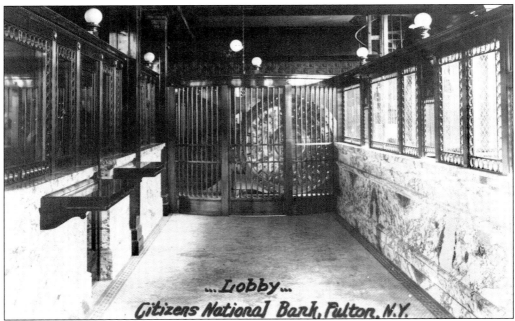

THE BANK LOBBY. This c. 1900 view shows the lobby of the Citizens National Bank. At that time, most banks had marble and mahogany in their interiors.

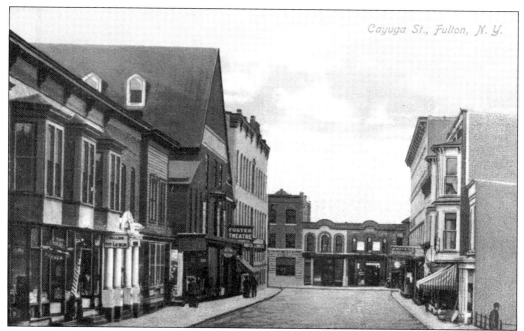

CAYUGA STREET. This view from Cayuga Street looks west to First Street, showing the Lewis Hotel on the right. The old Stevens Opera House, with the high peaked roof, is on the left.

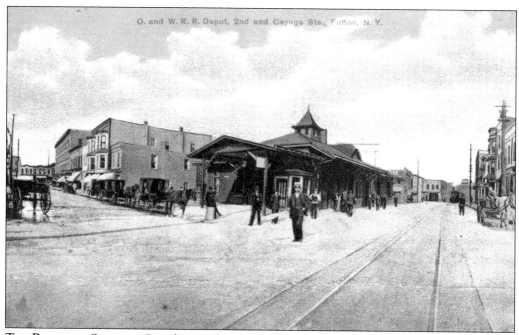

THE RAILROAD STATION. Seen here is the Ontario and Western railroad depot, on Cayuga and South Second Streets. The city installed a drinking fountain on the corner.

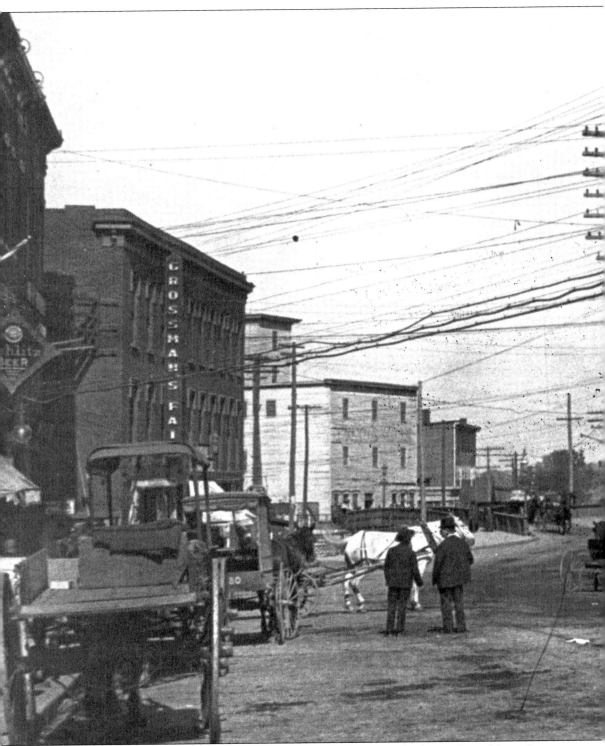

THE CORNER OF SOUTH FIRST AND CAYUGA STREETS. This view looks northward from Cayuga

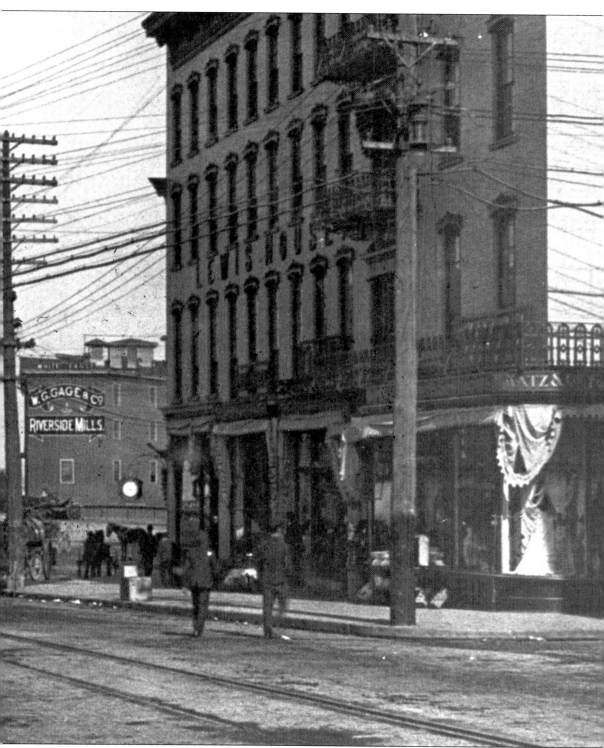

Street. The Katz Department Store, Lewis House, and Gage Mills can be seen.

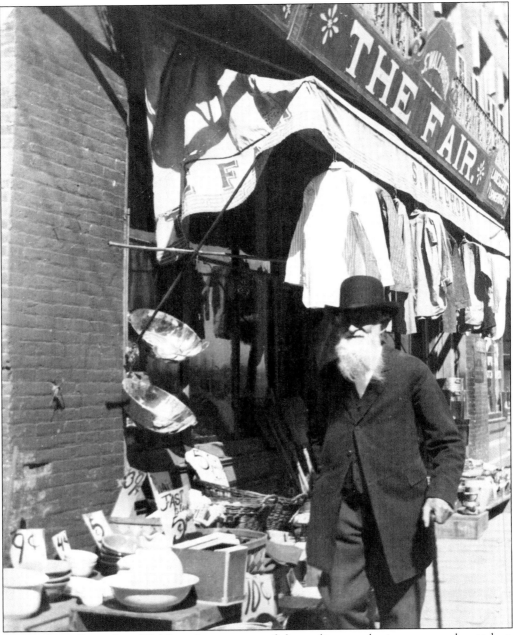

A Sidewalk Sale. Sam Waldhorn's store, one of the earlier area businesses, was located on the west side of South First Street between Cayuga and Oneida Streets, across from the Lewis House hotel.

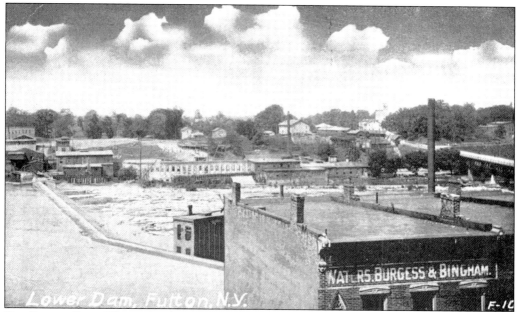

THE LOWER DAM. This early photograph, looking westward from South First Street, shows the mills along the west side of the river. The lower dam is on the left.

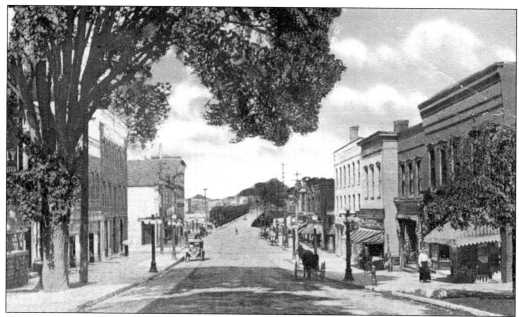

ONEIDA STREET. This photograph, taken between Second and Third Streets, looks westward toward the lower bridge. Oneida Street is the division line between the north and south in Fulton.

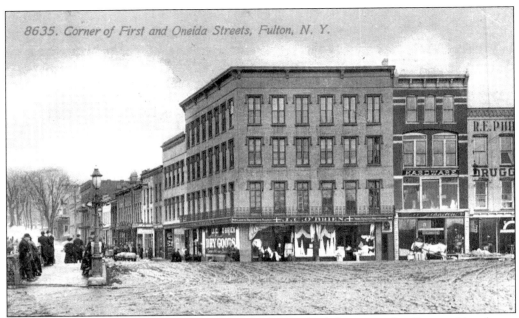

ONEIDA AND FIRST STREETS. The pedestrian bridge, at the left, crosses the Oswego Canal.

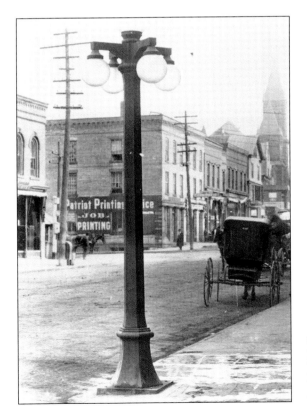

ONEIDA STREET. This view was taken looking eastward toward the First Methodist Church from the middle of the first block of Oneida Street. Note the attractive lamppost.

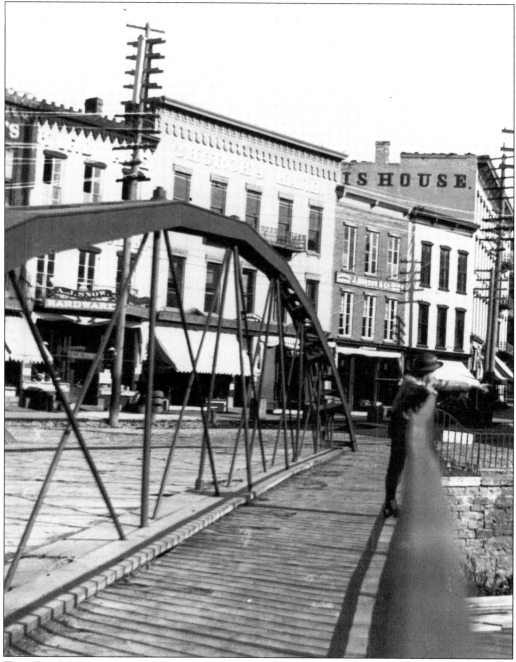

THE CANAL BRIDGE. This view looks down South First Street from the canal footbridge. Watching canal boats pass under the bridge was a popular pastime.

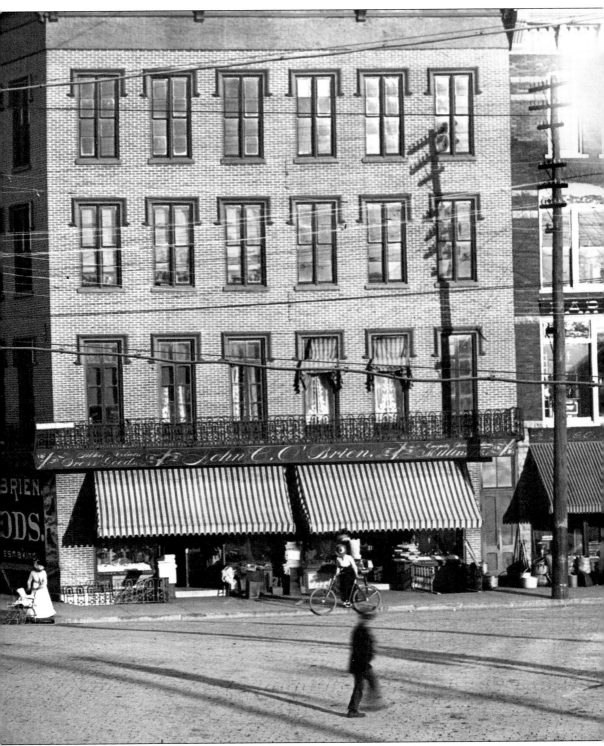

THE BUSINESS BLOCK. This is a photograph of Oneida and South First Streets in the early

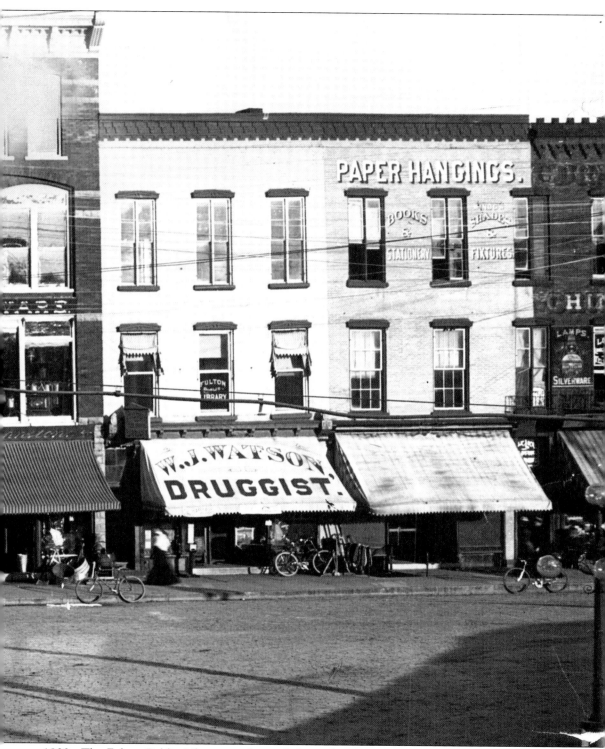

1900s. The Fulton Public Library was located above the W. J. Watson drugstore.

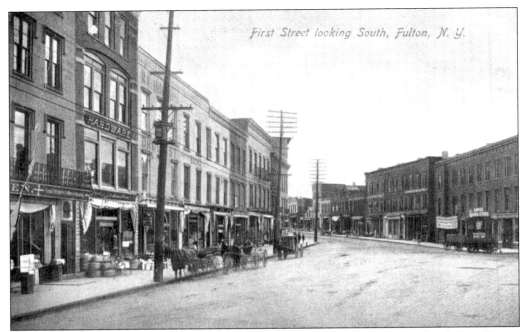

SOUTH FIRST STREET. This is an early photograph of the business district on South First Street, between Oneida and Rochester Streets. Before the trolley ran on South First Street, the horse and buggy was the popular mode of transportation.

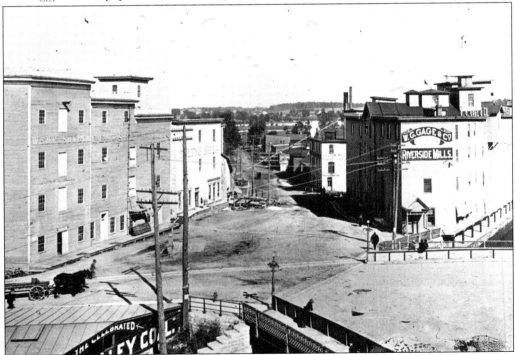

THE MILL DISTRICT. This South First Street view looks down North First Street into the mill district. The canal is on the right, next to the Gage Flour Mill.

Five
FULTON INDUSTRIES ALONG THE RIVER

The number of local flour mills decreased due to fire and an increase in midwestern grain production. The paper industries followed the flour mills, taking advantage of the inexpensive waterpower. Of the 16 mills at the height of manufacturing, only 3 remain today.

Many local plants were known nationally. The American Woolen Mills made woolen cloth for uniforms from the Civil War through World War II, as well as world-famous worsted cloth. Hunter Arms was known for L.C. Smith shotguns and Hunter fans, both of which were manufactured in Fulton. Hart pottery, which was made in Fulton and Oswego Falls, is a popular collectible item today.

Fulton's manufacturing was varied, and it is said that there was a payday in Fulton every day of the week. During the Depression, there was an article written and published in New York City stating that Fulton was the place the Depression missed.

In the years following World War II, many mills closed or moved away. Since then a few new companies have opened, but many local people commute to jobs in other cities.

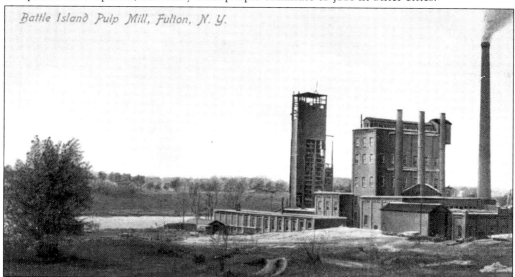

BATTLE ISLAND PULP MILL. This plant is located at the third falls, about three miles downriver. The falls and the dam are no longer at this location because the dams upstream were raised. Armstrong Cork managed this company for many years.

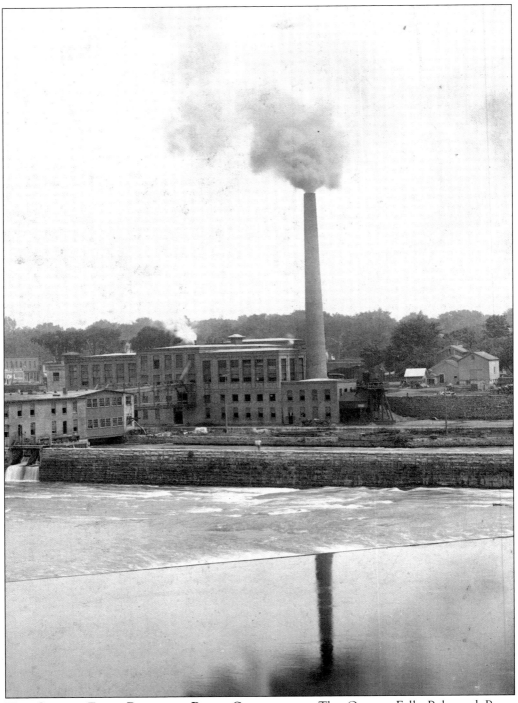

THE OSWEGO FALLS PULP AND PAPER CORPORATION. The Oswego Falls Pulp and Paper Corporation is located between the Broadway Bridge and the Oswego Falls on the east side of the Oswego River. The smokestack was a landmark. It is believed that the building on the right is where Hart Pottery made crocks for food preservation and storage.

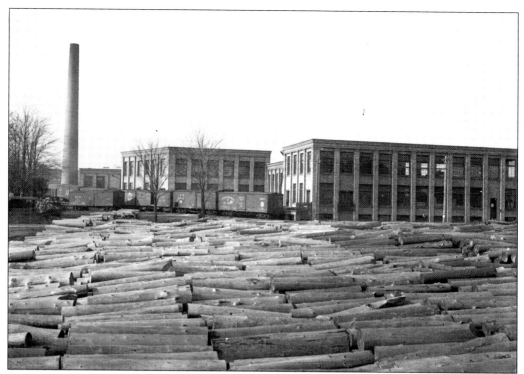

CANADIAN WOOD. In the manufacturing of cardboard for containers, Oswego Falls Pulp and Paper Corporation used pulpwood that was shipped here from Canada.

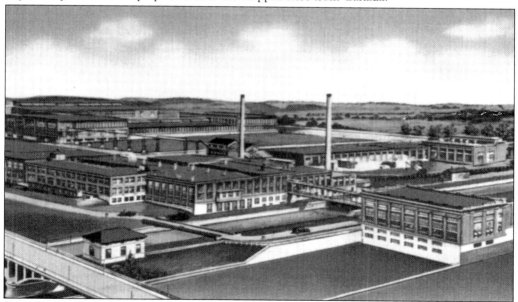

THE SEALRIGHT CORPORATION. The Oswego Falls Pulp and Paper Corporation added the Sealright Corporation, which produced wax-coated milk containers and bulk ice-cream containers. This photograph shows the river, the powerhouse, the canal, Sealright, and the pulp mill buildings.

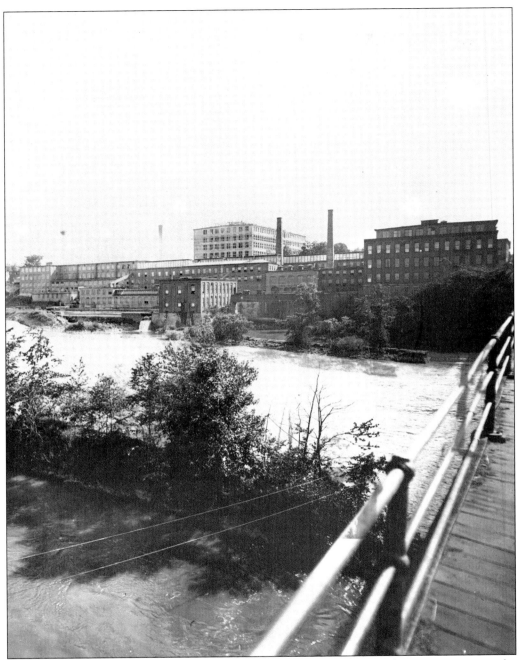

THE AMERICAN WOOLEN MILLS AND THE BROADWAY BRIDGE. For close to a century, the American Woolen Mills made fine worsted cloth for men's suits and strong woolen cloth for uniforms. Note that the bridge is made of wood.

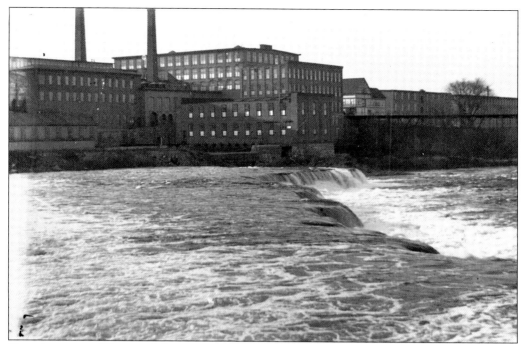

THE AMERICAN WOOLEN MILLS AND THE FALLS. This is a different view of the American Woolen Mills. Note the original formation of the Oswego Falls.

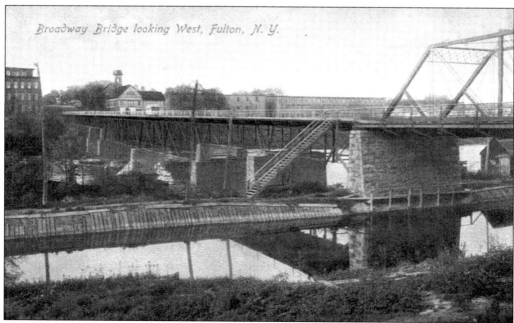

THE OLYMPIC SILK MILL. Over the Broadway Bridge in the center of the picture is the Olympic Silk Mill. Today, the mill buildings are apartments for senior citizens.

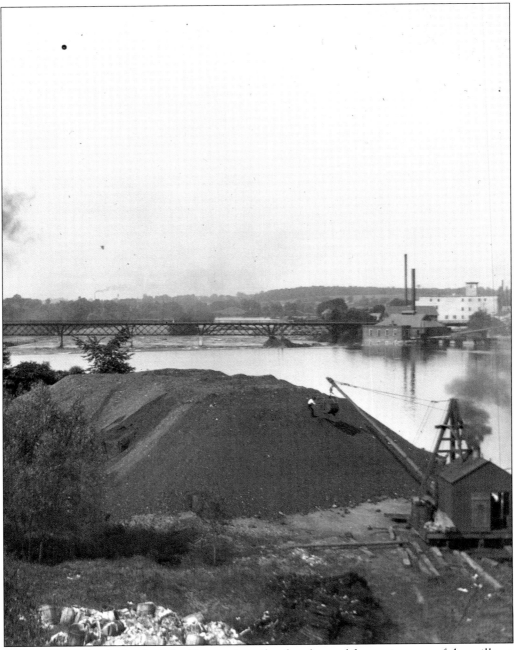

A COAL PILE. On the bank of the Oswego is a pile of coal stored for use in some of the mills on the west side of the river. The barges would leave the canal and than pole across the river.

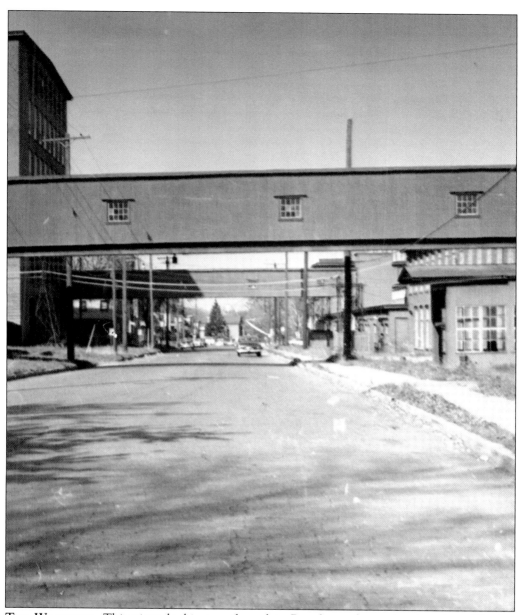

THE WALKOVER. This view, looking northward to Broadway, shows the American Woolen Mills on West First Street. The walkover was used for transporting goods from one part of the plant to another.

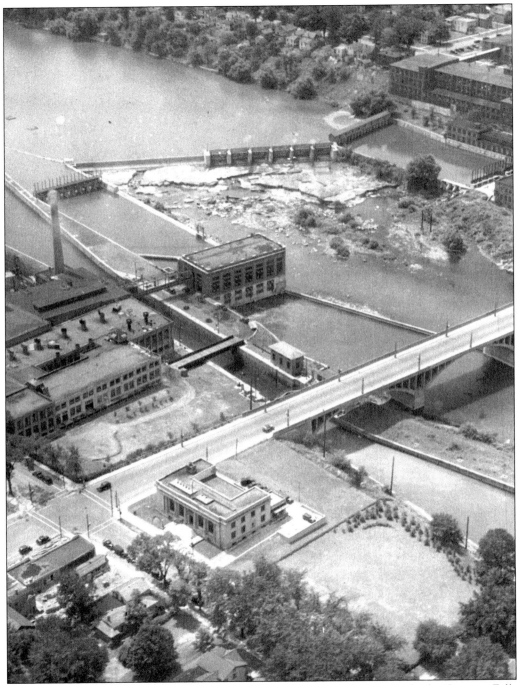

AN AERIAL VIEW. Seen here are the post office, Broadway Bridge, Sealright-Oswego Falls Corporation, and Barge Canal. Just below the dam, between the two powerhouses and their raceways, is the original riverbed.

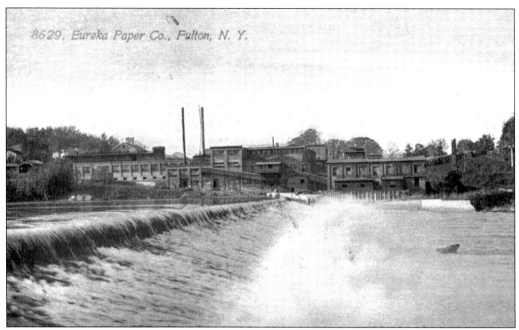

TWO MILLS. This view shows two mills and an electric generating station on the west side of the river near the lower dam. The smaller mill is the Velvet Tissue Company, and the larger one is the Eureka Paper Company.

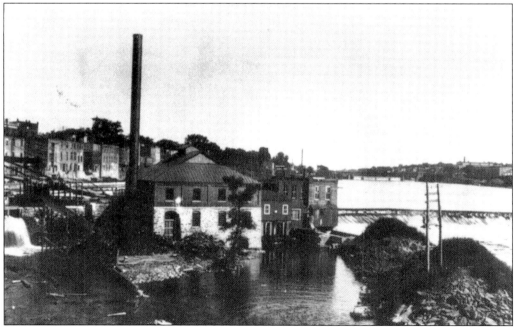

THE OLD POWERHOUSE. Here is a powerhouse for the Fulton Light, Heat, and Power Company, located at the east end of the lower dam and the small bridge over the canal.

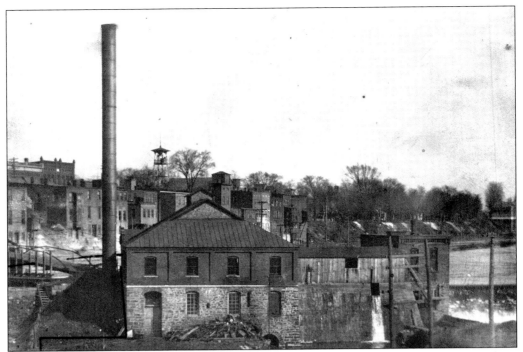

THE POWERHOUSE. The powerhouse at the east end of the lower bridge had an addition. There was a great need for more power. The small footbridge on the left goes over the Oswego Canal.

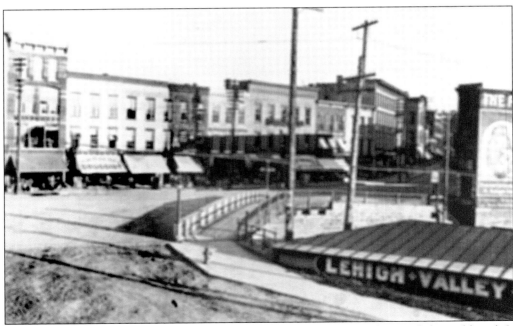

THE BUSINESS DISTRICT. Seen here is one of the establishments on the canal that sold coal. It was located at the east end of the Oneida Street Bridge next to the canal.

THE RAILROAD. The canal became less important to industry when the railroads built sidings going to the mills' shipping docks. Industries no longer had to depend on the river for transportation.

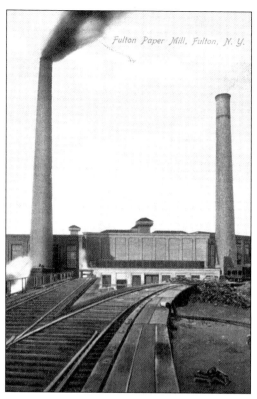

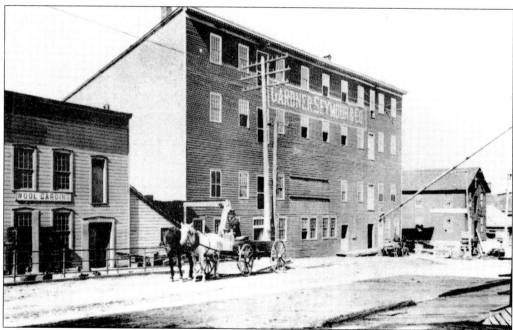

NORTH FIRST STREET. This view shows some of the mills on North First Street. The names of the mills are on the buildings. This area had mainly flour and paper mills.

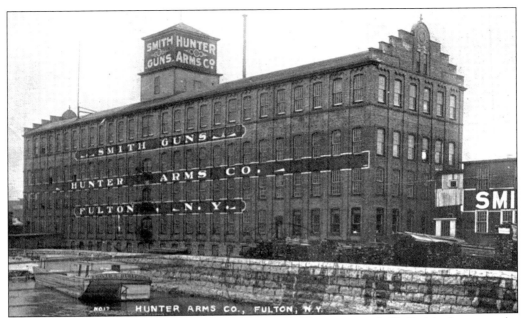

THE HUNTER ARMS COMPANY. This company made Hunter guns, L.C. Smith shotguns, the Hunter fan, and Hunter bicycles. Note the canal and canal boat in the foreground.

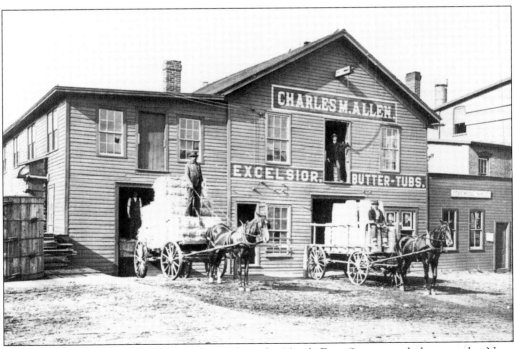

THE ALLEN FACTORY. This factory, located on the North First Street, made butter tubs. Note the loads on the transport wagons.

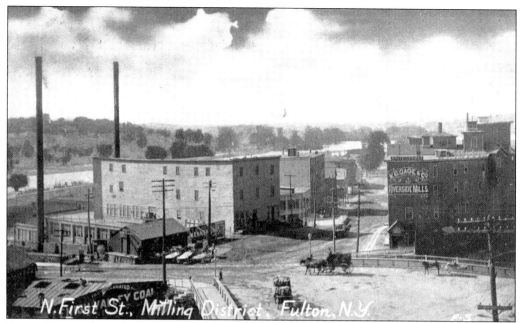

FLOUR MILLS. These flour mills were located on North First Street, north of Oneida Street. The river is in the background, and the canal footbridge in the foreground.

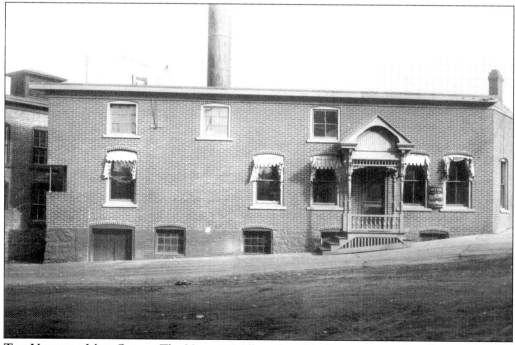

THE VICTORIA MILL OFFICE. The Victoria Mill produced bathroom tissue. Its office was located on North First Street across from the mill.

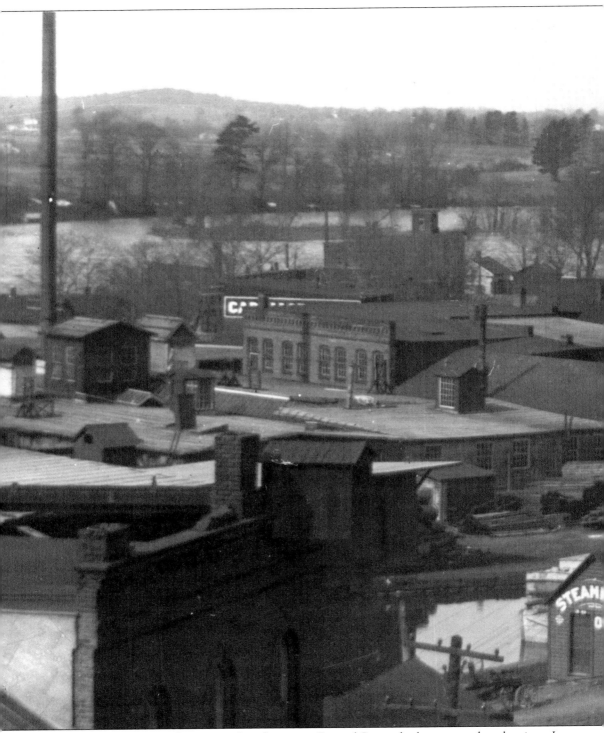

THE MILL DISTRICT. This view, taken from near Second Street, looks westward to the river. In the early 1900s, this was one of the busiest areas in Fulton. The mills and businesses are gone,

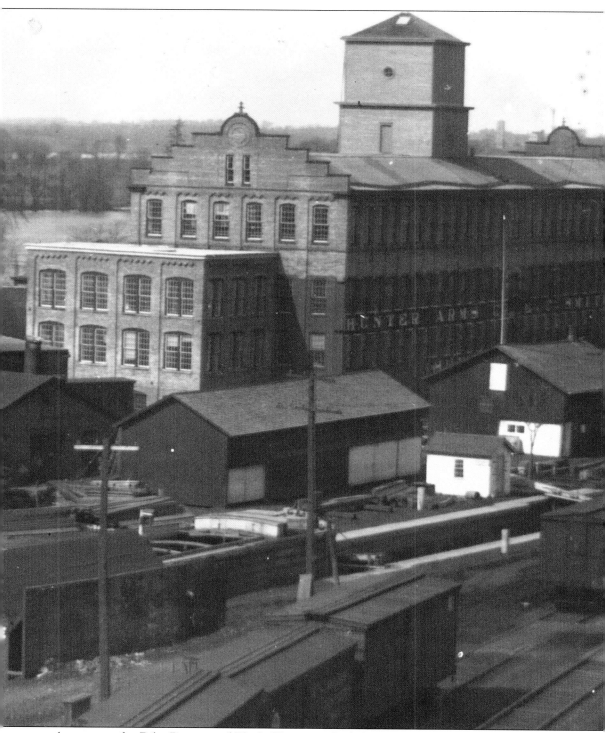

today, except for Dilts Division of Black Clawson, which has grown through the years. Note the barge tied up in the canal behind the steamboat office, in the center.

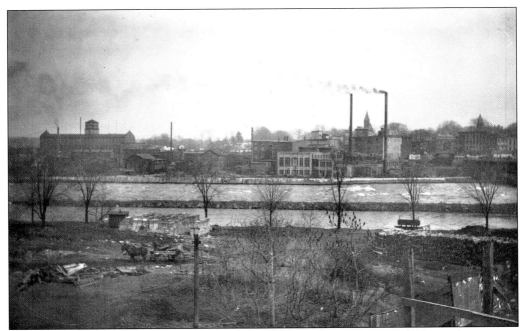

THREE COMPANIES. Taken from the west side of the river, this photograph shows the raceway from the power plant, the river, the canal, and the mill district, including the Hunter Arms Company, Volney Felt, and Victoria Mills.

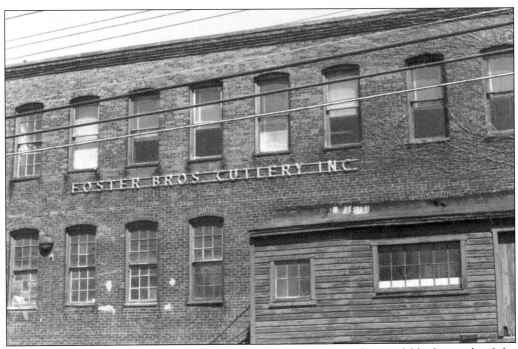

FOSTER BROTHERS CUTLERY. Foster Brothers Cutlery was located several blocks south of the lower bridge on West First Street. Foster knives are known worldwide.

Six

RECREATION AND LEISURE CONNECTED TO THE RIVER

The river offered many opportunities for recreation: picnics on the riverbank, ice-skating, and boating, to name a few. Of course, fishing has always been popular. Fireworks were always set off over the river. Entertainment was simpler many years ago, when more time was spent outdoors in physical activities.

In the early days, Pathfinder Island was a place for recreation. Later, Foster Park, located on the west side of the river, was a popular spot for picnics and ball games. More recently, a boat launch was built on the east side of the river near the city line to the north, and a marina is located south of the Oneida Street Bridge between Locks 2 and 3.

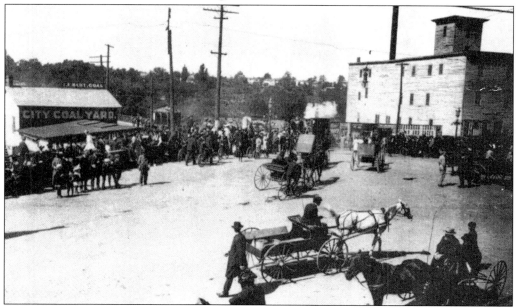

THE CIRCUS. People gather at Oneida and South First Streets to see the circus parade. It is hard to tell the spectators from the parade participants.

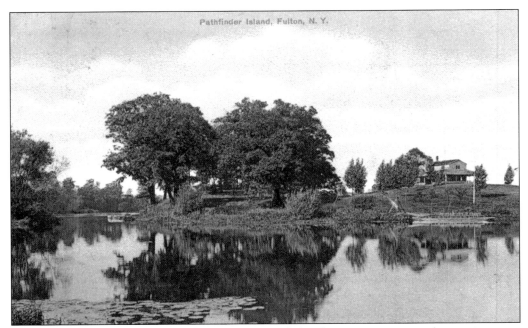

PATHFINDER ISLAND. In the early 1900s, one of the favorite recreation destinations was Pathfinder Island, located a little north of the city. There is a boat tied up at the landing.

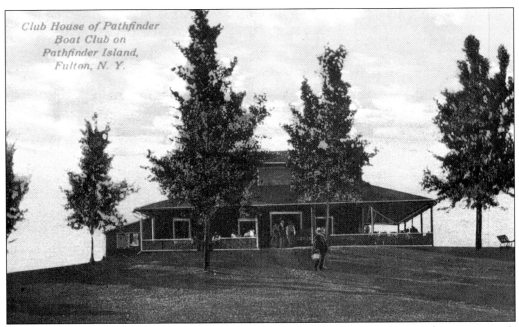

THE CLUBHOUSE. The island had a clubhouse that offered various activities. This was a men's club, but women were invited for special occasions.

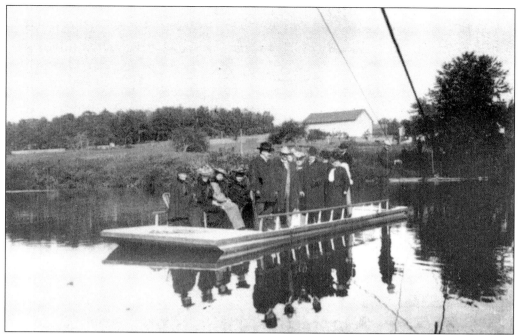

THE ROPE FERRY. From the east side of the river, people could take either the rope ferry or their own boat over to Pathfinder Island.

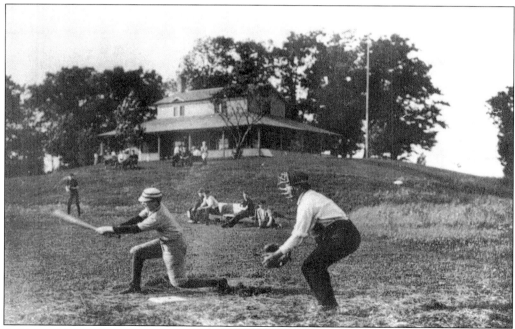

A BALL GAME. Picnics and games were favorite activities. In those days, only the boys played ball.

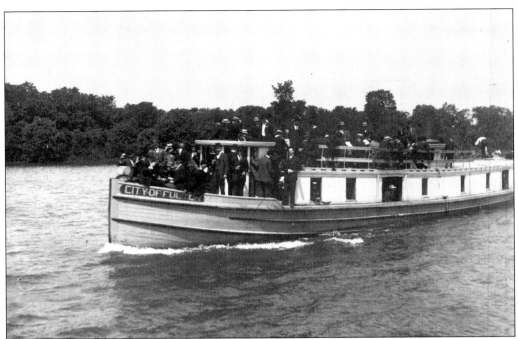

THE CITY OF FULTON The *City of Fulton* was an excursion boat used on the canal. Whether just out for a ride or going on a picnic, it was more fun to go with a group.

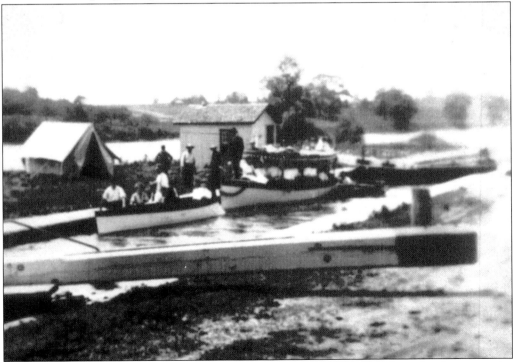

PLEASURE BOATS. Many pleasure boats plied the Oswego Canal. Note the beam in the foreground that opens or closes the lock, which was operated by hand.

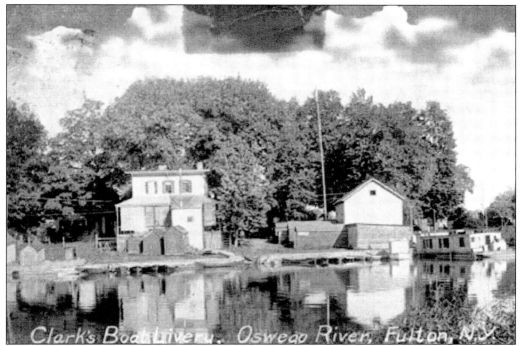

CLARK'S BOAT LIVERY. Clark's Boat Livery was located north of Fulton. People came here to rent boats, dock them, or even have repairs made.

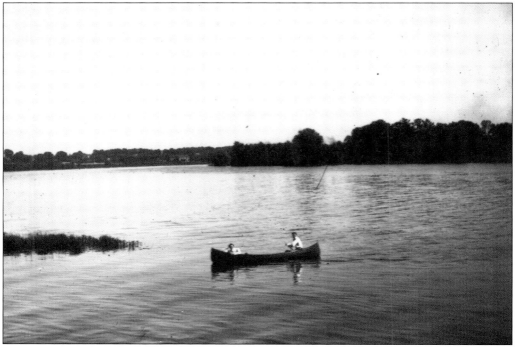

A CANOE. A couple is enjoying a leisurely ride on the river south of Fulton. The walls and towpath of the old Oswego Canal are still visible along portions of the river south of Fulton.

ROWBOATS AND CANOES. In the past, you could rent a boat to go up and down the river. Today,

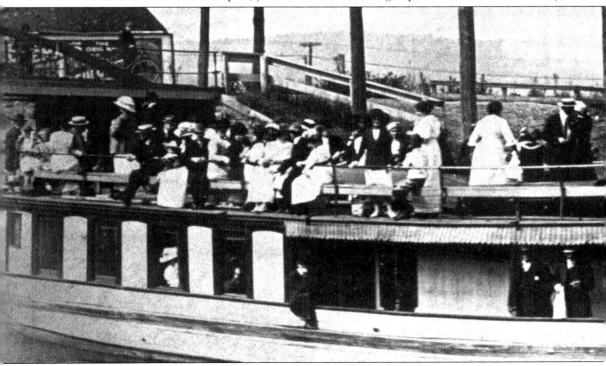

A PLEASURE BOAT. It may appear that these passengers are "cruising down the river on a

most people own their own pleasure boats.

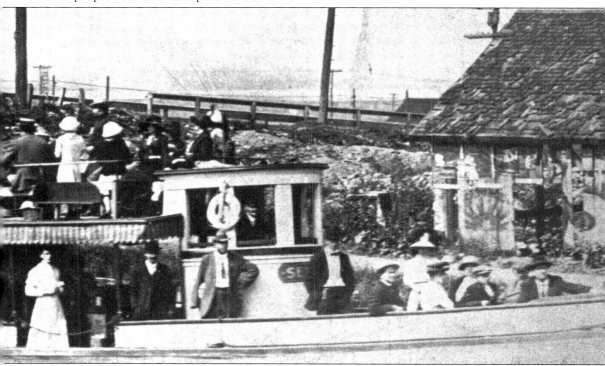
Sunday afternoon," but in this case they are enjoying the canal and not the river.

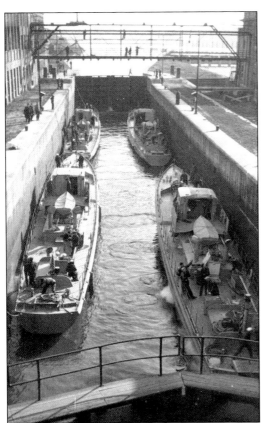

SOME PLEASURE BOATS. These pleasure boats are in Lock 2. The footbridge connects the Oswego Falls Corporation to the power station.

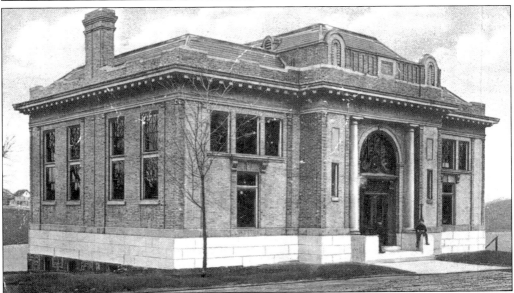

THE FULTON PUBLIC LIBRARY. Seen here is another landmark on the river. Many people found reading a book under a tree near the river a pleasant activity. Reading groups, held in homes, were very popular with women in the 1900s. One such group remains in Fulton today.

Seven

THE LATER YEARS

Because of the increased use of rail transportation and the use of electric power, produced by the power plants located along the river, Fulton's diversified industries were able to operate away from the riverbank. As the industries moved away from the river, so did people, other businesses and services, and recreation.

The river was used less and less for transportation and more and more for only recreation. Today, recreational use of the river is highly promoted by the state.

As the roads improved, major highways intersected the city. These highways are used for both recreational and industrial purposes.

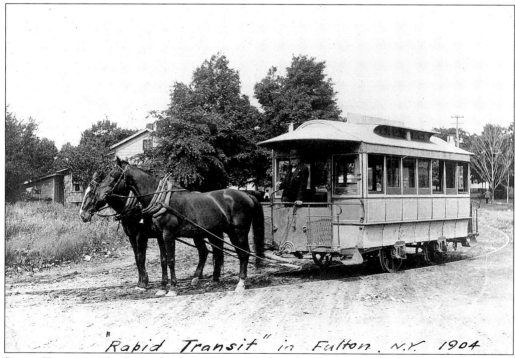

RAPID TRANSIT. The horse-drawn trolley went from South First Street downtown, across the upper bridge, to the Delaware, Lackawanna & Western train station and the fairgrounds. Fulton was one of the last cities to use this kind of transportation.

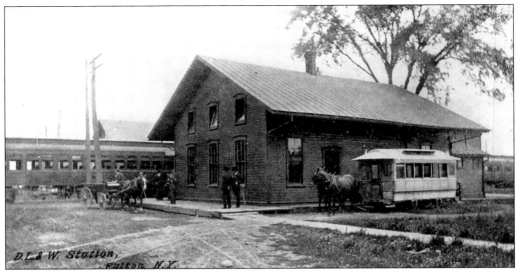

THE TROLLEY AT THE TRAIN STATION. This train station was near Lake Neahtahwanta on West Broadway. The DL&W was one of several train systems that went through Fulton.

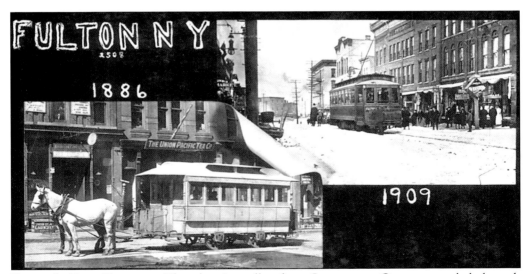

FULTON'S TWO TROLLEYS. The electric trolley from Syracuse to Oswego traveled through Fulton. Many people still refer to local places by the trolley stop numbers. Battle Island Golf Course is stop number 32.

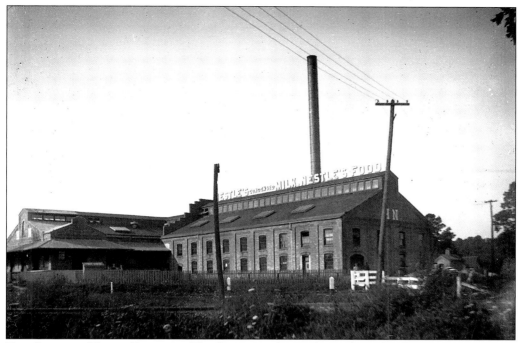

THE ORIGINAL NESTLÉ BUILDING. This factory made Nestlé condensed milk and Nestlé food for babies. The condensed milk continued to be produced after World War I. The plant is located on South Fourth Street, on the east side of the river.

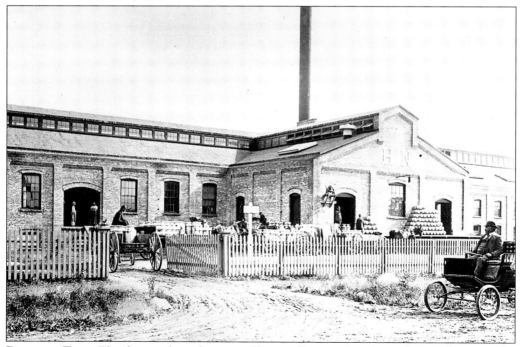

DELIVERY TIME. The farmers brought raw milk in milk cans directly to the condensery. The "HN" on the building stands for Henri Nestlé, owner of this Swiss company.

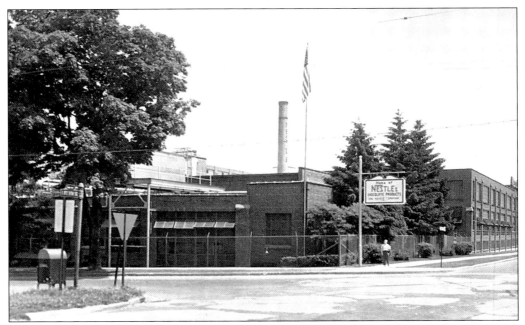

THE NESTLÉ PLANT. Nestlé chocolate bars are still being made in Fulton in the company's enlarged facility. Nestlé now markets other food products, including Taster's Choice Instant Coffee and Nestea.

AGRILINK FOODS. This food-processing plant began as the Stanwix Canning Company in 1902. It was sold to Snider Birdseye Packing, then to General Foods and, later, to Philip Morris. A 1968 fire led to the expansion and renovation of the vegetable-processing plant, located on Phillips Street, on the west side of the river.

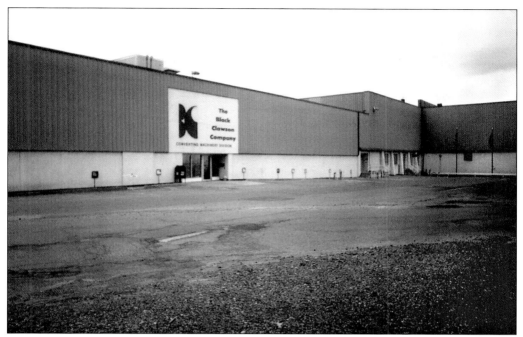

BLACK CLAWSON. The Dilts Division of Black Clawson, located on North First Street, is the only mill left in the old mill district. It produces machinery for the paper industry.

THE CHAMBER OF COMMERCE. This building is located on South Second Street, the east-side arterial. One of its functions is to promote the businesses and industrial activities of the city.

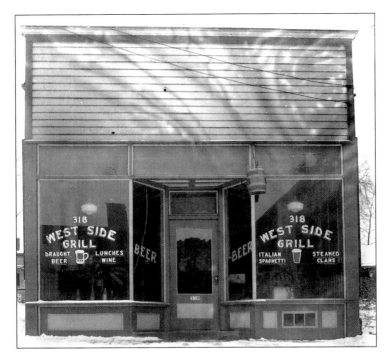

A STORE. This is the typical size of the small grocery stores that were located throughout the area. One remains today, and others are used as retail establishments. Most storefronts have been made into living spaces.

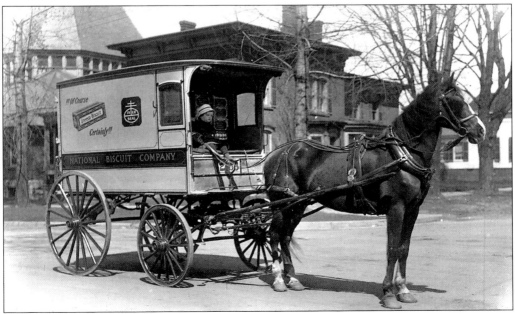

A DELIVERY WAGON. Horse-drawn wagons were used to make local deliveries. Ice, bread, milk, groceries, and other household items were delivered in this way.

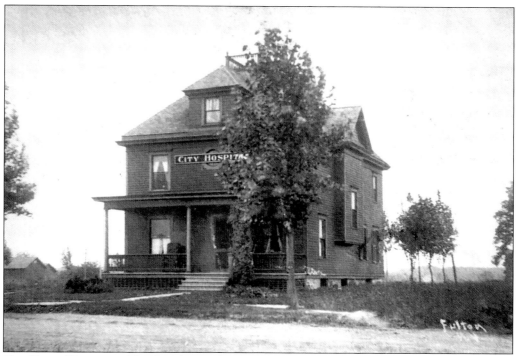

THE FIRST HOSPITAL. The first hospital in Fulton opened in 1904 in a home on West Fifth Street. It was established by a group of doctors, industrialists, clergymen, and lawyers.

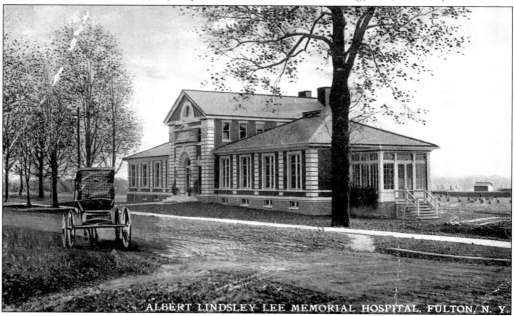

LEE MEMORIAL HOSPITAL. Before long, a bigger facility was needed. In 1908, Victorine Lee of New York City donated the land as a memorial to her late husband, Brig. Gen. Albert Lindley Lee, who was born in Fulton. Albert Lindsley Lee Memorial Hospital was built on South Fourth Street, on the east side of the city.

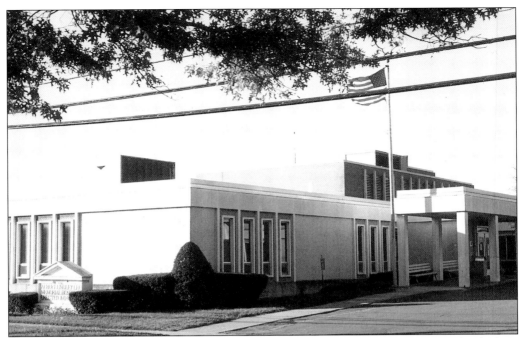

A MODERN HOSPITAL. The newest hospital opened in 1969. It is located just south of where the original Lee Memorial Hospital was erected. This larger up-to-date facility serves the city of Fulton and surrounding areas.

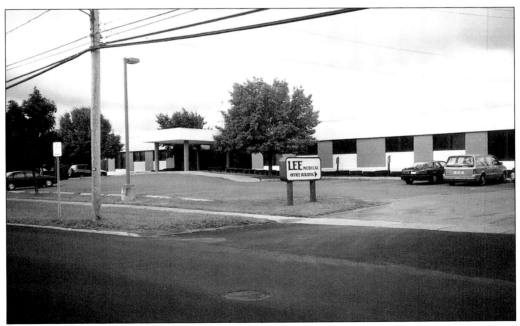

OFFICE SPACE. As local doctors got older and retired, steps were taken to attract new physicians to the area. Modern office space was built adjacent to the hospital as an incentive for doctors to come to Fulton to practice medicine.

THE MICHAUD NURSING HOME. As a large part of the area's population aged, a modern nursing home was needed. Michaud Nursing Home was built adjacent to the present hospital on the site of the first Lee Memorial Hospital.

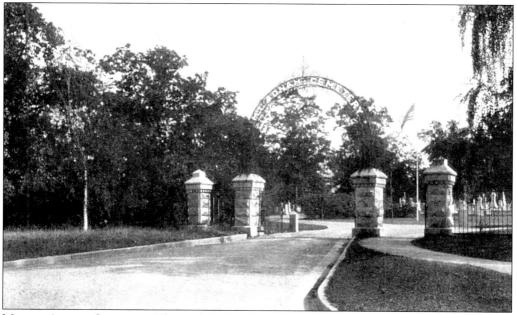

MOUNT ADNAH CEMETERY. This is the unique gateway at Mount Adnah Cemetery. Adnah is a Syrian word meaning rest or repose. This cemetery was established in 1858 and is located on East Broadway.

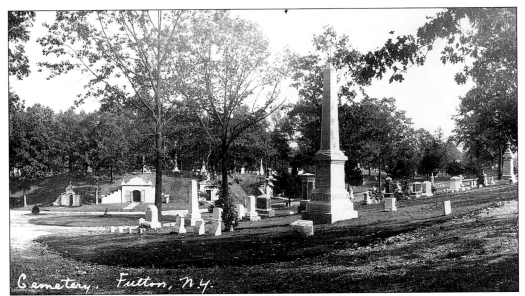

THE GRAVES OF LEADERS. Now on the National Register of Historic Places, Mount Acnah Cemetery was planned to be a peaceful place in a rural setting. This view is of the oldest area of the cemetery.

ST. MARY'S CEMETERY. Adjacent to Mount Adnah Cemetery, and separated by a chair-link fence, is St. Mary's Cemetery.

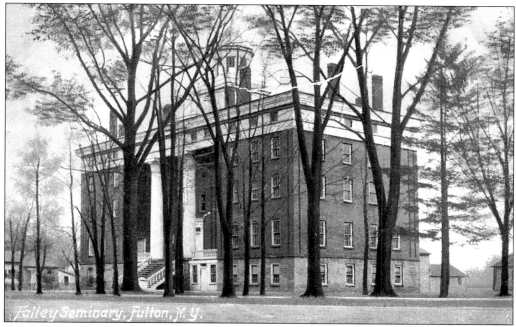

FALLEY SEMINARY. In existence from 1836 to 1883, Falley Seminary provided an academic course that was the pride of the area for postsecondary education. According to Fulton historians, the first curve ball was thrown by a Falley Seminary student during a baseball game in Fulton.

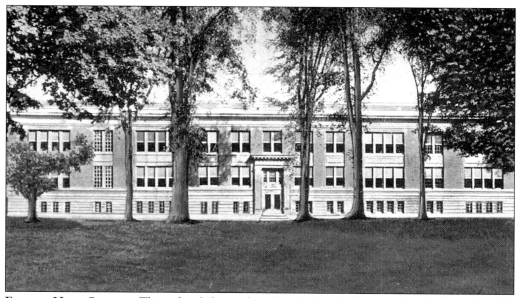

FULTON HIGH SCHOOL. This school, located on South Fourth Street where Falley Seminary once stood, served the city of Fulton from 1922 to 1965. The building now contains the offices of the board of education.

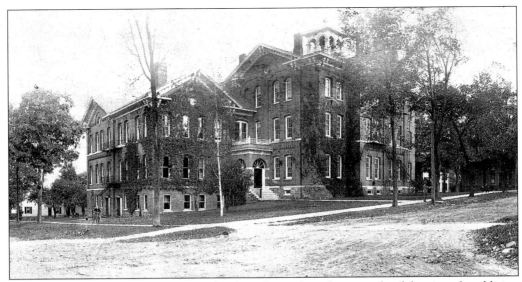

THE OLD FAIRGRIEVE SCHOOL. This school was located on the east side of the river. In addition to being a grade school, it was the high school for the village of Fulton. Later, the board of education had offices here.

SOME TOWNHOUSES. The old Fairgrieve School on South Fourth Street was torn down and these townhouses were built in its place.

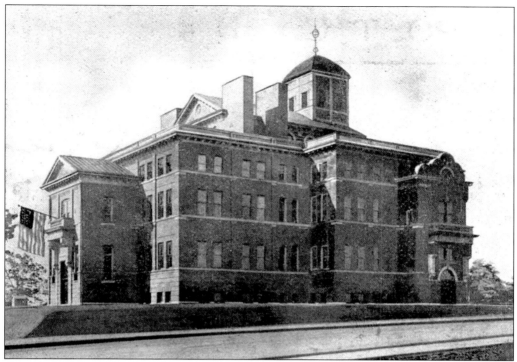

THE PHILLIP STREET SCHOOL. The Phillip Street School was located on the west side of the river. It was a grade school and high school for the village of Oswego Falls. The school was recently torn down.

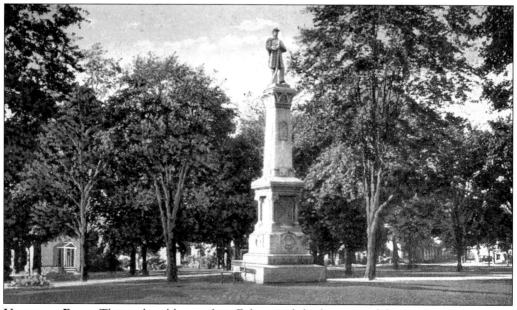

VOORHEES PARK. This is the oldest park in Fulton and the location of the Soldiers Monument. It was erected by the veterans of the Grand Army of the Republic. The soldiers served as part of the 147th New York Volunteers.

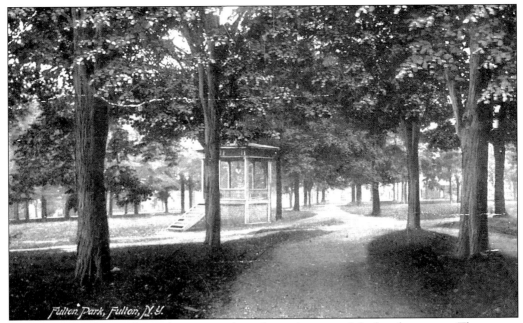

THE GAZEBO. The gazebo at the crossroads in the park was used for band concerts. There were also performances in the park by the Chautauqua Circuit, a traveling group of performers.

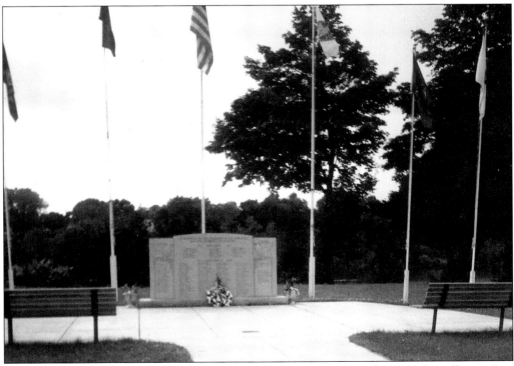

VETERANS PARK. This memorial was erected to honor all veterans who served in all wars. It is located on South First Street across from city hall.

A Parade on West Broadway. Sidewalks that were paved were a better place for a parade than the unpaved streets. The buildings shown here remain much the same today.

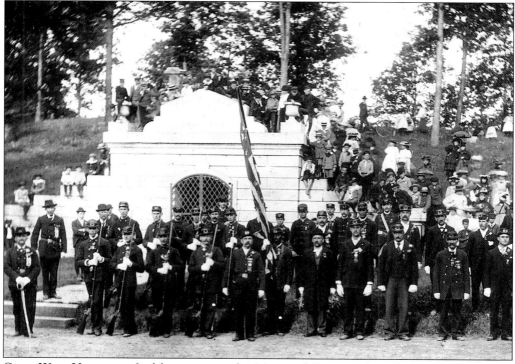

Civil War Veterans. Led by veterans, the Memorial Day parade ended at Mount Adnah Cemetery. Many onlookers came for the ceremonies.

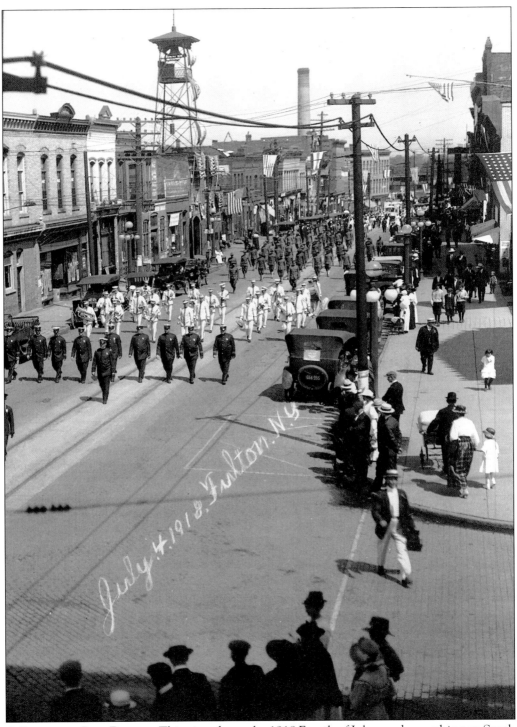

A FOURTH OF JULY PARADE. This view shows the 1918 Fourth of July parade marching up South First Street at Rochester Street. Note the early cars.

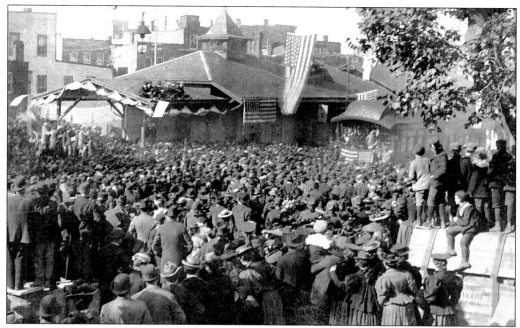

POLITICS AND TRAINS. Trains went through the center of the city on their way to the station, which was located downtown, on the corner of Cayuga and South Second Streets. Theodore Roosevelt's visit in 1901 was a reason for a crowd to gather. Some found creative ways to get a good view.

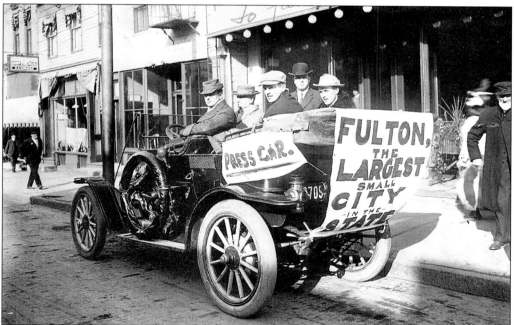

THE PRESS CAR. Car racing was popular in the early 1900s. This car was involved in a 1912 car race that went from Fulton to Fair Haven, a popular beach area located west of the city on Lake Ontario.

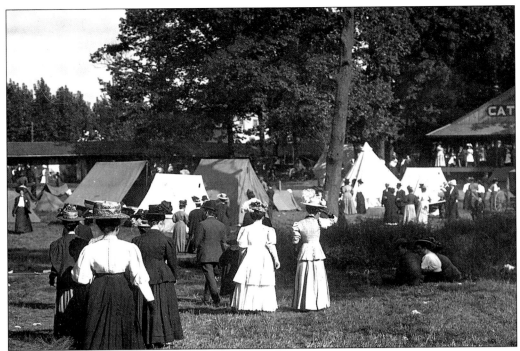

A Day at the Fair. Visitors are dressed in their Sunday clothes to spend the day at the Oswego County Fair. Many of them stayed in tents so that they could attend every day.

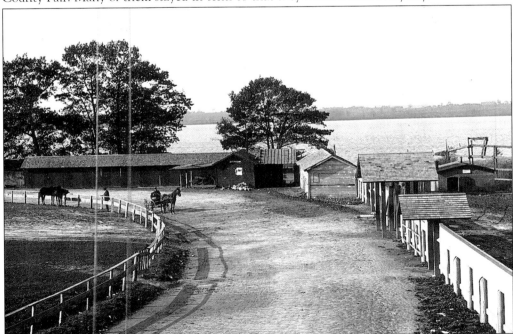

Horse Racing, c. 1900. Sulky races were a favorite feature for the fairgoers. The curve in the track goes past the shore of Lake Neahtawanta. There was a grandstand, and many people took advantage of the grandstand seats.

THE WAR MEMORIAL. This building on West Broadway, with its basketball court and pool, is on the site of an old dance hall. The dance hall was part of the early recreation park, which was once owned by the American Woolen Mills.

THE COMMUNITY CENTER. The building next to the War Memorial houses the recreation offices and the ice-skating rink. The baseball diamond and picnic area are behind it. At one point, there was a merry-go-round located here. The Oswego County Fair was held here for a number of years in the early 1900s.

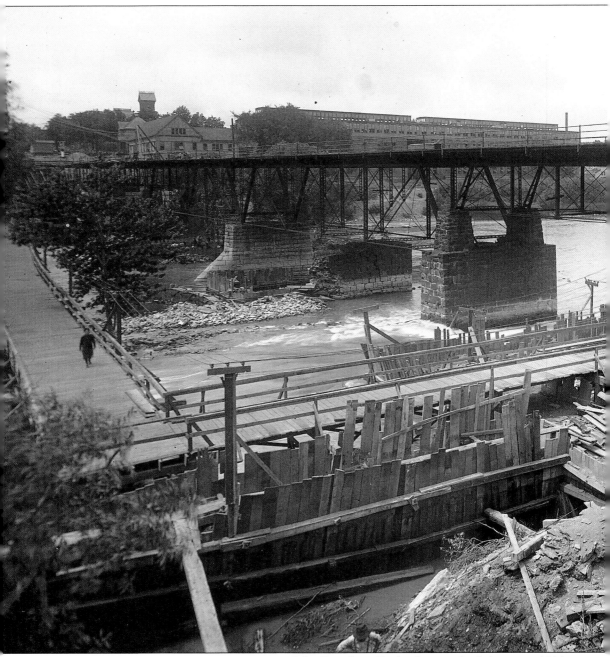

THE PEDESTRIAN BRIDGE. In anticipation of the Broadway Bridge being rebuilt between 1911

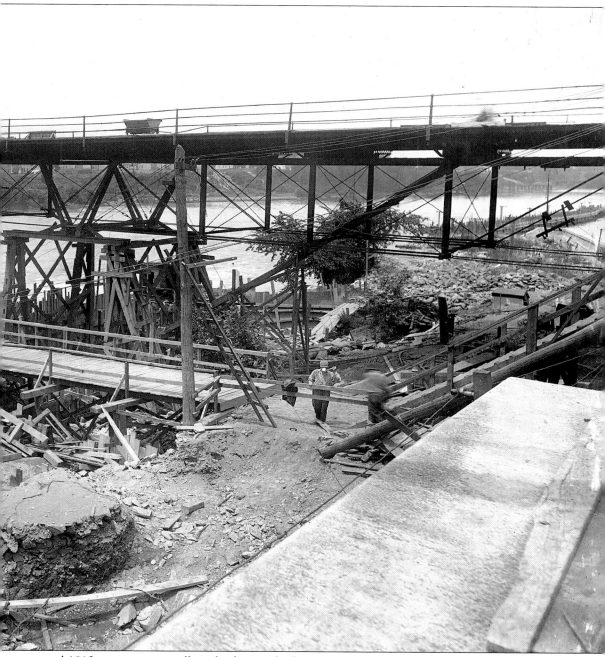
and 1913, a temporary walking bridge was built.

CANAL LANDING. This sign stands near the Oneida Street Bridge, on the east side. This area has been renovated, and the sign helps to promote the canal.

FULTON WELCOMES YOU. This sign, located on South First Street, welcomes boaters and visitors to the downtown area. Similar signs are located throughout downtown to aid visitors in finding local businesses and facilities.